LEONARDO DA VINCI
"La Bella Principessa"
THE PROFILE PORTRAIT OF A MILANESE WOMAN

LEONARDO DA VINCI

"La Bella Principessa"

THE PROFILE PORTRAIT OF A
MILANESE WOMAN

MARTIN KEMP AND PASCAL COTTE
with contributions by
PETER PAUL BIRO, EVA SCHWAN,
CLAUDIO STRINATI and NICHOLAS TURNER

HODDER &
STOUGHTON

First published in Great Britain in 2010 by Hodder & Stoughton
An Hachette UK company

1

Copyright © Martin Kemp 2010

A CIP catalogue record for this title is available from the British Library.

Hardback ISBN 978 1 444 70626 0

Typeset in Garamond by Jane Turner

Printed and bound by Graphicom, Italy

Hodder & Stoughton policy is to use papers that are natural, renewable and
recyclable products and made from wood grown in sustainable forests. The
logging and manufacturing processes are expected to conform to the
environmental regulations of the country of origin.

Hodder & Stoughton Ltd
338 Euston Road
London NW1 3BH

www.hodder.co.uk

FRONT COVER: Leonardo da Vinci
"La Bella Principessa": The Profile Portrait of a Milanese Woman
Private Collection

Contents

foreword

CLAUDIO STRINATI

This book provides an in-depth analysis of a work that can quite legitimately be termed "extraordinary". Drawn on vellum, in a complex and extremely refined technique, the profile portrait of a girl, dressed in the striking fashion of Milan at the end of the 15th century, turns out to be a possible new autograph work by Leonardo da Vinci. Leading Leonardo expert Martin Kemp has conducted his own research into this intriguing object and coordinated the work of numerous specialists from the fields of scientific analysis and art-historical discourse. Their findings are presented here.

"La Bella Principessa" has been submitted to extensive physical and scientific investigations from multiple points of view, including carbon-14 dating of the portrait's support and an analysis of all aspects of its formal execution. Using cutting-edge multispectral imaging techniques developed by his Paris-based firm Lumière Technology, co-author Pascal Cotte was able to study the materials and techniques of the portrait; to reconstruct, in a comprehensive way, the pigments used in its execution; and to identify the passages of restoration carried out over time. He combines this data to arrive at a virtual reconstruction of the original chromatic range that would

have characterized the work when it was executed by the artist. Further crucial support was provided by fingerprint expert Peter Paul Biro, who examined and assessed the portrait's compelling finger- and palmprint evidence discovered by Cotte in his ultra high-resolution images.

Martin Kemp's art-historical investigations were carried out with the utmost precision and thoroughness. The illustrious scholar explores the iconography and the deeper significance of the portrait, its style, and its relationship to works by Leonardo and other artists produced for the Sforza court in Milan. From this, he builds a conclusion based on solid academic grounds—one with a high degree of reliability.

Kemp, in fact, succeeds in demonstrating, beyond all reasonable doubt, that the portrait he has christened *"La Bella Principessa"* should be dated to the mid-1490s, exactly when Leonardo was in the service of Ludovico Sforza, Duke of Milan. With a full understanding of the literary and artistic culture of the Sforza court, he goes on to propose, by a process of elimination, that this work might be the first identifiable portrait of one of the Sforza princesses, Bianca, the Duke's illegitimate daughter (whom he later legitimized) by his mistress Bernardina de Corradis. Unable to establish incontrovertibly that the features are those of Bianca Sforza, Kemp offers his highly logical hypothesis with due caution, a reflection of the integrity and honesty of a true scholar.

In this book, we find a quantity of information and deductions, including a philological examination of the poetry tradition at the Sforza court, which take the reader on a journey of discovery—an exploration that leads slowly but inexorably to the conclusion that this can only be an authentic masterpiece

by Leonardo himself. It is, as Kemp notes, the accumulation of interlocking evidence that makes the case. As he further rightly points out, even the attribution of the *Mona Lisa*, arguably Leonardo's most famous painting, is based on a similarly plausible accumulation of evidence rather than on absolute certainty. Although much about *"La Bella Principessa"* is affirmed, not all questions can be answered, including where she lay hidden for centuries. This comes as no surprise. Many aspects of the study of Leonardo seem destined to remain unsolved, precisely because scholarship is hampered by the element of mystery that is so typical of great masters. (Indeed, it is that same mysterious dimension that can give rise to such fanciful popular creations as the *Da Vinci Code*!)

There is, by contrast, nothing fanciful about this book: it is based on concrete, carefully argued facts, all of which point to Leonardo as the author of *"La Bella Principessa"*. The scientific investigations confirm the date of the portrait and situate its origin in a fairly precise context. The conclusions are supported by the artistic quality of the portrait itself, which is exceptionally high: the tone of the facial expression, the incisive, but subtle contours and the delicate handling are all highly Leonardesque. One senses in the sitter a mixture of melancholy and strength. And, as Kemp fully demonstrates, her beauty transcends the best efforts of the Sforza court poets.

This book both can and *should* be read as a true and proper intellectual contribution to our knowledge of Leonardo's Milanese career, a period about which there is still so much to be learned. The portrait presented in this volume constitutes a valuable addition to Leonardo's *oeuvre* and reaffirms his absolute genius in the artistic panoply of his time.

Authors' Acknowledgements

In their quest to provide a comprehensive historical and technical analysis of *"La Bella Principessa"*, the authors have incurred debts too numerous to mention individually. However, pride of place must go to Peter Silverman, who has eagerly facilitated study of the original and sanctioned the scientific analysis undertaken by Lumière Technology in Paris. Giammarco Cappuzzo assisted in the early stages, above all with the carbon dating. The art historian Jo Ann Caplin, who is directing a series of television programmes on art and science, provided enthusiastic encouragement during the viewing process.

Martin Kaufman and Madelaine Slaven of the Bodleian Library, Oxford, advised on the identification of the vellum. Alessandro Vezzosi, who was the first to publish the drawing, generously allowed us to illustrate his overlay of *"La Bella"* with the Windsor drawing of the *Profile of a Lady*. Juliana Barone drew attention to an important text in the Forster Codex. Nathan Flis assisted Martin Kemp in tracing and transcribing sources, while Alesandra Buccheri took on the initial translation of the often tricky texts of the Milanese court poets. Evelyn Welch generously shared material about

10

women's fashion at the Sforza court.

During the course of research, a number of scholars have provided valuable observations and posed telling questions, expressing provisional or more developed opinions, many favourable and a few less so. It is not our intention here to provide a series of endorsements for the attribution, but mention must be made of Carlo Pedretti, whose researches have been so central to our understanding of Leonardo for more than five decades. He examined the work and the multispectral images with Pascal Cotte, and his early and steadfast recognition of *"La Bella"* as a highly significant new work by Leonardo is of special importance. Mina Gregori has brought a lifetime of research and looking to bear on her endorsement of Leonardo's authorship. Among younger scholars, Cristina Geddo, who approaches the drawing as a specialist in the followers of Leonardo, has provided valuable support in her discussions of the portrait's left-handed shading with Pascal Cotte and by stating that, in her opinion, none of the Leonardesque draughtsmen in Milan could have produced it. In the late stages of the book's preparation, Claudio Strinati, Ministero per i Beni e le Attività Culturali, Rome, kindly lent his support to the project by contributing the foreword.

Pascal Cotte acknowledges the assistance and advice he received from Eva Schwan, conservator for the Patrimoine, Paris, who has endorsed his findings and collaborated on the chapter about the drawing's restoration. He would also like to thank Alexandro Vezzosi, director of the Museo Ideale Leonardo da Vinci, for giving him an opportunity to present his findings at a lecture in Rome, and Jean Penicaut, President of Lumière Technology, for his support of this study, which

enabled him to handle a work by Leonardo for the third time.

Following Lumière Technology's discovery of a fingerprint and a handprint on the portrait, the authors turned to Peter Paul Biro, Director of Forensic Studies, Art Access & Research, Montreal, to analyse this evidence in the context of what was known of Leonardo's work. They are grateful to him for having agreed to contribute a dedicated chapter to the book on this subject. Biro's research stands at the start of what we hope will be a larger project on prints in Leonardo's paintings. For the present, he has to struggle with images not made for his purposes and obtained in markedly different ways: this latter problem more generally bedevils the technical examinations undertaken in different institutions and organizations.

The authors are most grateful to Jane Turner for her rigorous editing, translation of Cotte's text from French and (with husband, Nicholas) of Strinati's foreword from Italian, as well as her perceptive layout of the text and illustrations.

Finally, we end with what might be termed an "anti-acknowledgement". It was hoped to hold an exhibition in at least one appropriate publically funded museum or gallery to coincide with the publication of the evidence in this book. A number of galleries in different countries expressed initial enthusiasm, but each eventually declined to proceed. The underlying reasons were almost always the same: besides issues of security and the high cost of insurance, there was an ethical concern that their involvement might be exploited or misconstrued as part of a process of sale. But it is not the portrait's fault that it is not owned by a public gallery at this point in its history. And we should remember that almost all of Leonardo's output was made for private patrons. As the most

important rediscovered work by the artist in over a century, it surely deserves to be known and to be enjoyed in the original by the public at large. It is therefore with gratitude that we thank Excellent Exhibitions, AB, of Malmö, Sweden, and Mats Rönngard in particular, for providing the first official showing of the portrait in the context of the larger exhibition :*And There Was Light: Michelangelo, Leonardo, Raphael—The Masters of the Renaissance Seen in a New Light*.

Martin Kemp
Emeritus Professor of the History of Art
Trinity College
Oxford University
Oxford OX1 3BH
United Kingdom
www.martinjkemp.co.uk

Pascal Cotte
Director of Scientific Research
Lumière Technology, S.A.S.
215bis, blvd Saint Germain
75007 Paris
France
www.lumiere-technology.com

Preface

NICHOLAS TURNER

Since I was apparently the first to suggest seriously that the work that is the subject of this book might actually be by Leonardo rather than by a later pasticheur, the authors have kindly invited me to summarize the early story behind this exciting discovery and how the attribution to the master came to be endorsed by leading specialists in the field.

Little is known about the portrait's provenance and early history. It appeared as "the property of a lady" in a sale of Old Master drawings at Christie's, New York, on 30 January 1998 (lot 402), where it was described as "German School, Early 19th Century". Among its distinctive technical features were a vellum support and an unusually wide range of graphic media, comprising pen and brown ink, black and red chalk, and extensive bodycolour. The drawing—for that is in effect what it is, in spite of looking like a painting (the parchment ground being laid down on to an oak panel, with extensive use of brush and bodycolour, and a layer of varnish or sealant)—seemed to pass virtually unnoticed at the time. It must, however, have been seen by many of the leading Old Master drawings collectors, curators and dealers who gather in New York at the end of each January to attend what are widely regarded

14

as among the season's most important sales. Certainly, no one seems openly to have queried Christie's assertion that this was a 19th-century imitation of an Italian Renaissance prototype by some unnamed German Romantic artist.

At the sale, the lot was bought by the drawings dealer Kate Ganz, who paid $21,850 (the hammer price was $19,000). Nine years later, in January 2007, at an exhibition held in her New York gallery, she sold it on under the same attribution and for the same price, less a dealer's discount, to Peter Silverman, acting on behalf of an anonymous collector. The label at the time of her 2007 exhibition apparently read: "A carefully rendered study, this portrait is based on a number of paintings by Leonardo da Vinci and may have been made by a German artist studying in Italy." The hypothesis that the head is a conglomerate of details taken from a number of different paintings by Leonardo—which, of course, it is not—was not elaborated further.

Having myself missed the 1998 sale in New York, my first encounter with the portrait occurred in the autumn of 2007, when I was shown a good colour transparency of it and asked my opinion by a London dealer to whom it had been sent by a colleague. The attribution had changed in the interim, and by then it was given to an anonymous Italian Renaissance hand. Apart from the work's very high quality, what immediately struck me—even from the transparency—was the extensive left-handed parallel hatching (most conspicuous in the background, behind the girl's profile, where it provides additional contrast to her features in highlight). As is well known, the most famous left-handed Renaissance artist was Leonardo da Vinci. Both the handling and the invention of the beautifully

idealized figure were, to my mind, consistent with Leonardo's authorship (however extraordinary such a conclusion might seem on the face of it). That the portrait did indeed appear to be late 15th-century Italian certainly seemed to warrant serious research. My opinion was given a polite hearing but was ignored, and I heard nothing more of it for some time.

When, in January 2008, I bumped into Peter Silverman in the Italian picture galleries of the Louvre, he described to me a Renaissance portrait on vellum of a young woman in profile that he had acquired for a client and on which he had recently been working. I realized that this must be the same portrait as the one of which I had been shown a transparency. Now I had tabs on this fascinating work, and its whereabouts were no longer a mystery. I urged Silverman not to rule out Leonardo's authorship, on account of both the left-handed shading (the artist's "signature feature") and the very high quality of the work overall. Since I am not a Leonardo specialist, I recommended that he should show an image of it to as many experts on the artist as possible and that at the same time he should have it submitted to a proper technical examination.

Over the following weeks and months, there followed a flurry of letters, emails and phone calls in our attempts to see whether or not the Leonardo attribution would fly. First to be contacted were several Italian specialists working on Milanese drawings of the 15th and 16th centuries, among them Professore Giulio Bora, an expert on the Cremonese and Milanese schools, and Dottoressa Cristina Geddo, who has worked extensively on Leonardo's Milanese followers, such as Giovanni Antonio Boltraffio, Marco d'Oggiono, Gianpietrino Ricci and the Master of the Pala Sforzesca. Bora recognized

that the costume of the sitter was Milanese of the late 15th century; he further observed that the geometric patterns in the caul and bodice and the left-handed shading throughout seemed to point in favour of Leonardo and not a follower, but he was reluctant to commit himself without seeing the work in the original. Geddo immediately gave her support to the Leonardo attribution (later issuing a statement to this effect dated 2 July 2008).

On 5 March 2008, I finally had a chance to study the portrait in the original and was reassured to find that it fully lived up to the expectations raised by the transparency. Any lingering "It's-too-good-to-be-true" concerns were immediately put to rest when confronted by the work's great beauty and refinement. On that same day, Mina Gregori, Professor Emerita of the University of Florence and President of the Fondazione Longhi, inspected the work first-hand and stated independently that, in her view, it was by Leonardo. In the meantime, Alessandro Vezzosi, Director of the Museo Ideale at Vinci and one of the first Leonardo experts to have been contacted about the portrait, not only supported the attribution, but published it in his book *Leonardo Infinito*, which appeared in July 2008. He suggested that it was a nuptial portrait of a young Milanese woman whose hair is worn in a typical late 15th-century *coazzone* or plait.

To establish once and for all that *"La Bella Principessa"* was a late 15th-century work and not some sort of 19th-century pastiche, a proper scientific analysis of the piece had to be undertaken. In the spring of 2008, Silverman assigned the task to Lumière Technology, a Paris-based company founded by Pascal Cotte that specializes in multispectral digital imaging

and which has had extensive first-hand experience of Leonardo's work. Silverman was careful not to say by whom he thought the work might be, but was naturally elated when Cotte afterwards told him that all the data suggested only one result—Leonardo. Lumière Technology's findings, presented in detail in these pages, were fully supported by the results of carbon-14 dating tests carried out on the vellum support by the Institute for Particle Physics (IPP), Eidgenössische Technische Hochschule (ETH), Zurich.

During the summer of 2008, Professor Martin Kemp, one of the world's leading experts on Leonardo, inspected *"La Bella Principessa"* and concluded that it was an important, autograph work by the master and embarked on the present study. Over succeeding months, favourable views from a number of other Leonardo specialists began to accumulate, including that of Professor Carlo Pedretti. So the idea that the portrait was indeed by the great Renaissance master gradually took hold.

Once a 19th-century date had been ruled out on scientific grounds, the only other possibility to be seriously considered—and ultimately rejected—was that *"La Bella Principessa"* might be by one of Leonardo's close Milanese followers. As Dottoressa Geddo pointed out, however, the portrait's style and handling differ significantly from those of portrait drawings by any of the Leonardeschi. Strongly influenced by their mentor, these followers were, without exception, right-handed—which effectively excludes their authorship. Although they might be capable of emulating the forms, techniques and style of their master, they could not copy his left-handed shading or mirror writing. It is nonetheless instructive to examine surviving works by these followers, since they provides clues

18

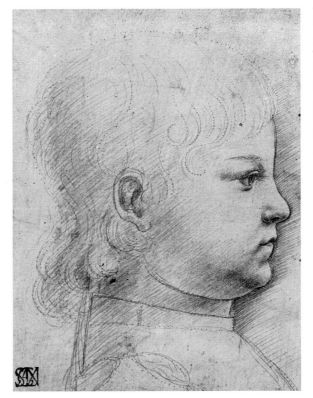

Figure a

MASTER OF
THE PALA
SFORZESCA

*Profile Portrait
of Massimiliano
Sforza,* 1494

Milan, Biblioteca
Ambrosiana

to the prototypes by Leonardo that must have been available
to inspire them.

Let us consider, for instance, the Master of the Pala
Sforzesca's *Profile Portrait of Massimiliano Sforza* (fig. a), a pricked
study in the Ambrosiana, Milan (inv. no. Cod. F 290 inf. 13),
for the child at the lower left of the artist's altarpiece of 1494
(see fig. 28). Drawn in metalpoint on faded blue prepared
paper, the portrait is conceived in very similar formal terms,
with the highlight of the strictly rendered profile emphasized
by the contrasting diagonal (clearly right-handed) parallel

hatching in the adjacent background. As sensitively observed as this study is, especially in the facial features, the contour is much harsher and less subtle, and the rendering of the sitter's hair betrays a lack of three-dimensionality, especially at the back of the head. Leonardo's instinctive understanding of volume is replaced in this instance by an interest in surface texture and decorative curls.

That one or more models by Leonardo must have been behind the unusual and still innovative practice of drawing portrait or head studies in coloured chalks is suggested by the work of another of the Milanese followers, Giovanni Antonio Boltraffio, including, for example, his *Portrait of a Woman (the so-called Isabella of Aragon) as St Barbara* (fig. b), also in the Ambrosiana (inv. no. Cod. F 290 inf. 7). Although the model is shown in contemporary dress, this is not in fact a portrait but a study for the artist's *St Barbara* altarpiece, which was commissioned in 1502 for the chapel of St Barbara in Sta Maria presso S Celso, Milan (now in the Gemäldegalerie, Berlin). The woman is shown full-face rather than in strict profile, but she has the same stateliness and poise as *"La Bella"*, a similar sense of volume, and the same strength of handling. Nonetheless, the drawings are not by the same author, and it is clear that the artist responsible for the *St Barbara*, like the Master of the Pala Sforzesca, was right- rather than left-handed (see the pronounced shading in charcoal in the costume). Moreover, Boltraffio's coloured chalk drawing of *St Barbara* lacks Leonardo's disciplined, precise penwork, giving it a softer and far more pictorial effect. For all the stylistic and technical parallels, neither it nor any of Boltraffio's drawings has the subtlety and refinement of *"La Bella"*. As is so often the case,

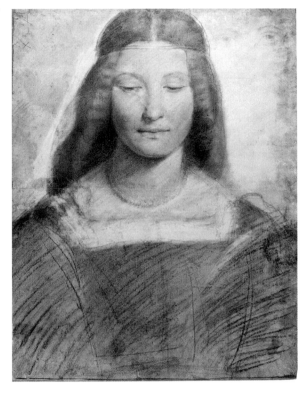

Figure b

GIOVANNI
ANTONIO
BOLTRAFFIO

*Portrait of a
Woman as St
Barbara*

Milan, Biblioteca
Ambrosiana

the work of master and follower remain strikingly distinct.

In short, the extraordinary new portrait presented in this volume looks like a Leonardo, its vellum support dates from his lifetime, and not a single one of his followers had the skill to execute a work of this degree of sophistication. As will become clear in the comprehensive essays that follow, there are plausible reasons to explain how it should have remained undiscovered for centuries. One simply rejoices that it has now re-emerged to be appreciated by scholars and visitors to the Gothenburg exhibition in early 2010 and long thereafter.

Part 1: From Style to Sitter

MARTIN KEMP

1. Introduction

A young lady, or a girl on the cusp of maturity, is costumed for a formal portrait. Her fashionable accoutrements are those of a Milanese court lady in the 1490s. She wears a green dress, under which is a red bodice. The shoulder of the dress is "slashed" to reveal a triangle of red. Green, red and white were favoured by the Sforza family, rulers of Milan. Around the aperture runs a continuous knot design in raised thread. The central flourish at the top of the knotwork is punctuated by embroidered points. Her light brown hair, glowing and tightly bound, is elaborately dressed with a caul of knotted ribbons, edged by a smaller interlace design. It is held in place by a thin band located at precisely the right angle on her forehead. Extruding from the net, her pigtail—the Milanese *coazzone*—is bound into a neat cylinder by a tightly circled thread. Below this binding, a flat ribbon disposed in two spirals constrains the long tresses of her hair, only a little less strictly.

The details are beautifully observed. Her ear plays a subtle game of hide-and-seek below the gentle waves of her hair. The band pulls the rear profile of the caul into a slight concavity. Below each band of the spiralling ribbon, her hair swells slightly before it is constricted again by the next loop.

24

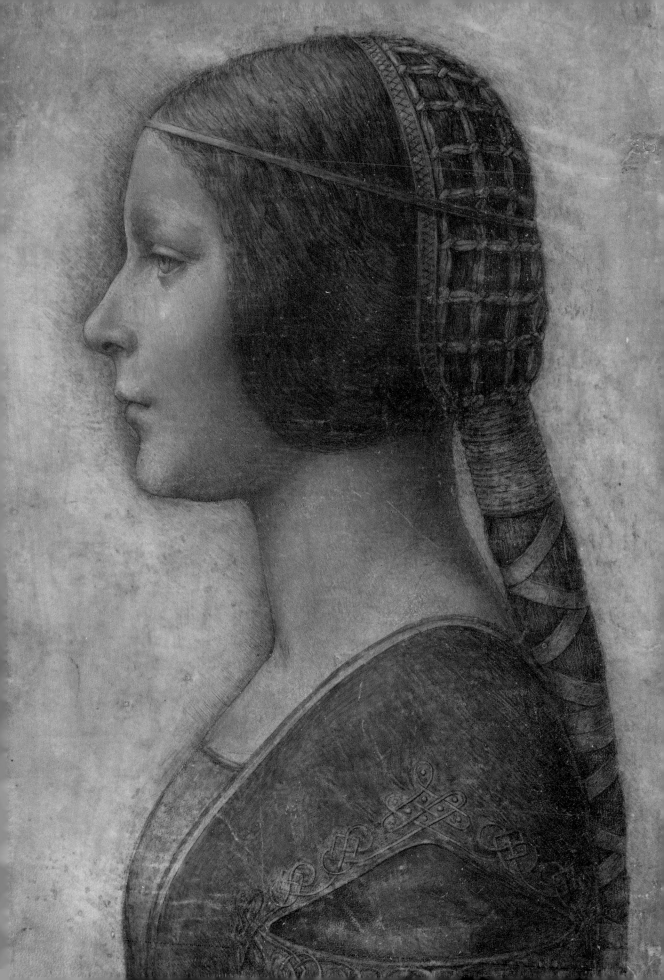

The profile of her face is subtle to an inexpressible degree. No contour, no convexity, no hollow lapses into a steady, mechanical curvature. The line is incised with stiletto-like precision, yet retains a vivid sense of life. The evenness of her features nowhere falls into routine generalization. Those aspects of the faces of beautiful women most extolled by Renaissance poets—roseate lips and eyes like stars—are drawn with infinite tenderness. The iris of her pensive eye retains the translucent radiance of a living, breathing person. Her eyelashes, especially those on her lower eyelid, are so fine as to elude a casual glance. The tip of her upper lip barely touches the pink curve of her lower lip with the utmost delicacy.

Can we sense a tension between the fresh innocence of the young lady and the formal courtly duties that her costume signals as her destiny—before she has become a mature woman ready for the fixed responsibilities of aristocratic marriage and the hazards of childbearing? She is, we may be reasonably certain, fated to become a young bride, betrothed early to cement social allegiance.

It is not difficult to be romantic about such an image. It is almost too perfect in its refined poise. This can be the only possible explanation for its having been first assigned to a German plagiarist of the 19th century, when it emerged at auction at Christie's in New York on 30 January 1998.[1]

Like the British Pre-Raphaelites, the Nazarene painters from Germany who haunted the Spanish Steps in Rome in the early decades of the 19th century aspired to recreate the art of the Renaissance, particularly in its more simple and "pious" phases. Artists such as Friederich Overbeck, Franz Pforr and Peter Cornelius sought to reverse 300 years of art history.

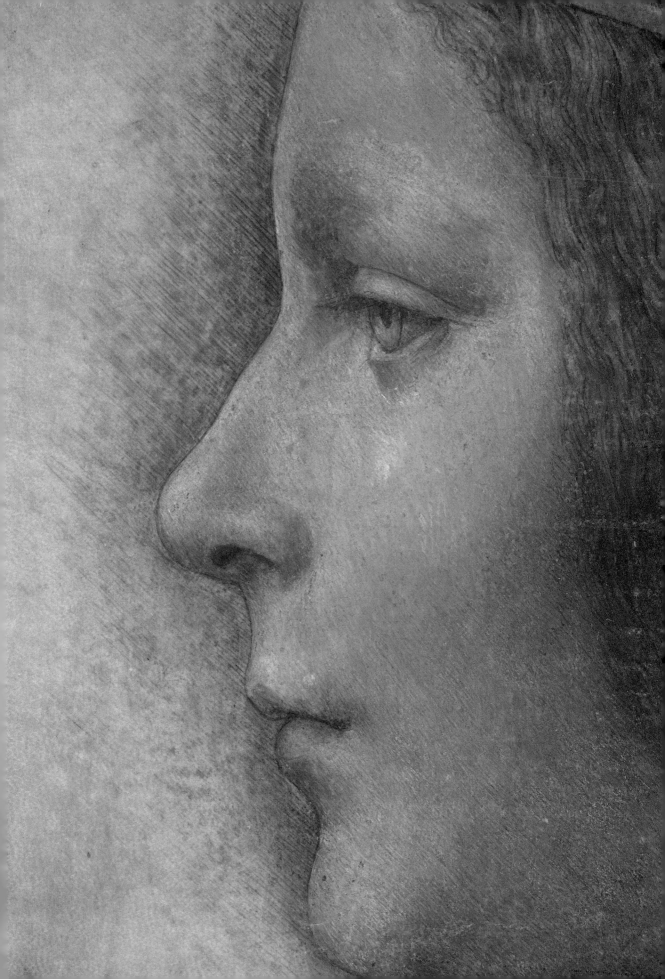

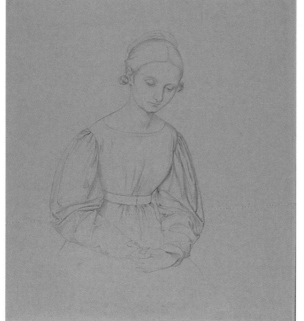

Overbeck's drawing of his wife (fig. 1), related to his painting of *Italia and Germania* (1828),[2] exemplifies their draughtsmanship. Overbeck could draw with great delicacy, but there is a discernible gulf between the restrained precision of his outlines and the living contours of the profile portrait.

We are, for reasons that will become abundantly clear, dealing with the "real thing", not with the skilled work of a 19th-century pasticheur. After repeated viewings, scientific analysis and intensive research, I have not the slightest doubt that the portrait I am calling *"La Bella Principessa"* is a masterpiece by Leonardo da Vinci. First recognized as Leonardo by Nicholas Turner, it has been confirmed at an early stage as an autograph

28

work by Carlo Pedretti, Alessandro Vezzosi, Mina Gregori and Cristina Geddo.[3] The present book is the first comprehensive examination of this extraordinary discovery.

A major, previously unknown work by Leonardo is the rarest of rare things. A few, relatively slight drawings have appeared in the last 50 years. There have been a host of untenable attributions and a smattering of top-class forgeries. The most spectacular rediscovery involved the identification of the two long-lost codices in the Biblioteca Nacional, Madrid, in 1967.[4] But nothing like the present drawing has emerged. Indeed, the term "drawing" is something of an understatement, since the beautifully modulated hues and tones of the portrait are produced by a subtle interplay between coloured chalks and pen and brown ink. Executed on vellum (parchment), it is a highly finished, luxury product—a "painting" in chalks that exhibits the highest levels of tonal, colouristic and formal skill.

All the crucial aspects of the portrait, from its striking appearance, its scientific examination and its likely function, testify to its authenticity. Let us begin with the hard facts of its physical properties.

2. Medium and Scientific Examination

The drawing is executed on a relatively large sheet of vellum (330 x 239 mm), currently laid down on an old oak board. There is evidence, particularly in the diagonal hatching to the left of the woman's profile, that the artist first used an unusually fine and hard black chalk, sharpened to a point. The main features of the image were then established with great delicacy and subtlety in pen, with a relatively translucent brown ink of a kind with which we are familiar in Leonardo's drawings. Coloured chalks, mainly red (pink in dispersed quantities) with traces of black in the shaded areas, were used to establish the flesh tones, with the natural colour of the vellum providing the yellowish tint that would normally be supplied by yellow pigment. Areas of the flesh have been softly worked over with white chalk. The colour of the hair is established with pen and brown ink over blended red and black chalk. Details of the face, hair, headdress and costume, such as eyelashes and the knot designs, have been emphasized in pen and ink. The red and greens of her dress have, as Pascal Cotte demonstrates, been achieved very economically and subtly in coloured chalks, without the actual use of a green pigment. It may be that gum arabic (mentioned by Leonardo, as we will see) was used as a fixative, so that the dry chalks would not be

subject to rubbing or transfer to an abutting surface. We will also see that in his writings he talked about recipes for making chalks that did not smudge.

A sliver of parchment was taken from the lower left margin and subjected to carbon dating at the Institute for Particle Physics in Zurich (see p. 110). The result gives a highly probable date range of 1440–1650, which greatly diminishes the possibility of the portrait being a clever forgery. The media proved to be entirely consistent with those in use around 1500.

The main examination was undertaken by Pascal Cotte of Lumière Technology in Paris, using his unique multispectral imaging system. This records optical data at unprecedentedly high resolution in bands across the entire light spectrum, from ultraviolet, through the frequencies of visible light, to three bands of infrared. The Lumière Technology equipment (fig. 2) has also been used to examine the *Mona Lisa* (Paris, Louvre)[5] and the *Cecilia Gallerani* (*"Lady with an Ermine"*; Kraków, Czartoryski Museum).[6] Infrared data was also obtained by

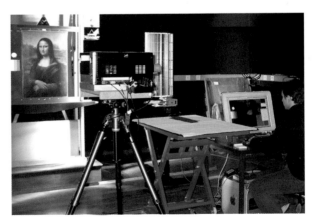

Figure 2

Multispectral analysis of the *Mona Lisa* by Lumière Technology at the Louvre, 2004

transmission through the image. The spectral composition of the light from specific areas was matched against the known spectral composition of pigments. "False-colour" images were produced to highlight difference in pigments, not least in those areas subject to restoration. Images in raking light from the side and below were obtained. The data from various scans were combined to produce a comprehensive picture of the "archaeology" of the portrait. The work was also X-rayed.

The examinations are fully documented in Part II by Pascal Cotte and Paul Biro. For the moment, we may summarize the main findings in as far as they substantially affect our understanding of the making and condition of the portrait:

1. The vellum and the pigments have undergone the kinds of damage, abrasion and restoration that are to be expected with an object dating from the late 15th century.

2. The shaded areas were first laid in with extensive parallel hatching in Leonardo's distinctive left-handed manner (i.e. the strokes inclined from upper left to lower right, often at or close to a 45° angle). Such hatching is seen more extensively in the infrared images than by the naked eye. The hatching in the background to the left of the woman's profile, unlike the general modelling of the face, appears to have been started at the inked contour, passing upwards to the left (fig. 4), rather than downwards, in order to minimize the transgressing of the facial contours.

3. The opaque areas of pigment on the forehead, cheek and neck result from an old campaign of restoration, to cover areas of damage and losses to the original chalk surface.

4. The darker ink reinforcements added with the brush, most

evident in the headdress, hair and costume, also result from restoration, undertaken piously to "improve" the image in a way that differs from modern procedures. It is evident that the retouchings were made by a right-handed artist.

5. The light brown washes apparent in the hair and elsewhere present a trickier problem, not least because there are no discernible brushstrokes that might betray their author's graphic habits. Cotte is inclined to see all the washes as later, but Leonardo used translucent ink washes extensively in his drawings, and both Nicholas Turner and I are inclined to see at least some of those in the hair as original, and perhaps also those outside the contours of the profile.

6. A left fingerprint is evident close to the left margin at the level of the woman's hairline (fig. 3).

7. There are clear signs that some part of the artist's hand, probably the outside of the palm of the right hand, have been pressed into the pigment layer in the sitter's neck.

8. The base colour of the vellum is left uncovered or little covered in some regions of the head as a way of endowing

Figure 3

Detail of fingerprint on left edge of *"La Bella Principessa"*

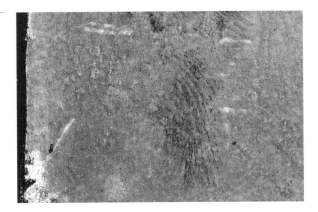

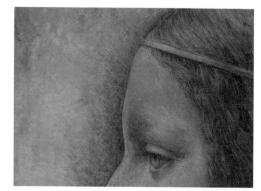

Figure 4

Detail of left-handed shading, starting at the contour of the sitter's face and moving upwards to the left

Figure 5

Detail of areas of the vellum left blank by the artist to convey the sheen in the sitter's hair

Figure 6

Detail of damage to vellum where the knife evidently slipped when the portrait was cut from a manuscript

the flesh with colour. This effect is used notably in the radiant iris of the eye. The sheen in the upper regions of her hair is achieved in the same way (fig. 5).

9. The contours of the facial profile, neck and shoulder reveal some manoeuvring (*pentimenti*) to establish the right outline; there are also signs that the rear contour of her caul was first laid in further to the right of its present location.

10. The upper, right and lower edges of the sheet are consistent in appearance and may be original. The left edge has been cut more jaggedly and shows signs of three stitching holes. A crooked, double vertical incision within the margin in the lower left third bears witness to a knife having slipped when the sheet was being cut (fig. 6). This evidence indicates that it was once bound in a manuscript, before being excised and laid down on panel.

11. The relatively regular distribution of tightly spaced follicles suggests that the vellum is from the skin of a calf.

The evidence of the finger- and handprints is explored in detail by Paul Biro in Part II below. At a historical distance of more than 500 years, no forensic evidence is likely to be wholly conclusive. We cannot, after all, take prints from Leonardo's own hands. However, the likely correspondence of the fingerprint found on *"La Bella"* with prints on Leonardo's unfinished *St Jerome* (Rome, Pinacoteca Vaticana)[7] is an important piece in the jigsaw of technical and stylistic evidence.

Leonardo, vellum and coloured chalks

There are no other known works by Leonardo on vellum, but there is previously neglected evidence of his interest in mak-

ing coloured images on prepared animal skin. Unsurprisingly, he knew of the technique of using oiled kidskin for tracing,[8] as recorded by Cennino Cennini in his *Libro dell'arte* of the late 14th century.[9] However, the most intriguing passage occurs in Leonardo's so-called "Ligny Memorandum" in the *Codice atlantico* (Milan, Biblioteca Ambrosiana),[10] a rough draft that uses a simple code to conceal his intention to travel with the French general to Naples—a journey he seems not to have undertaken. Later in the note he writes:

> *Get from Jean de Paris the method of dry colouring and the method of white salt, and how to make coated sheets; single and many doubles; and his box of colours; learn the tempera of flesh tones, learn to dissolve gum lake....*[11]

"Jean de Paris" is Jean Perréal, the French portrait painter, illuminator, designer, intellectual, poet and man of many parts, who visited Italy in the train of the invading French kings. He seems to have been in Milan with Charles VIII in 1494 and with Louis XII in 1499, and perhaps on other occasions. The "method of dry colouring" refers to coloured chalks, presumably like those in Jean's "box of colours". Leonardo is planning to ask the French master about ways of preparing the drawing surface, while his desire to obtain single and as many double sheets as possible clearly refers to the cutting of rectangular pages from the irregular, stretched skin of a kid or calf. He also intends to seek guidance on how to achieve flesh tones and to handle lake pigments with a gum binder. Gum, or more fully "gum arabic", is extracted from the acacia tree and can be used as a binder for pigments or even as a fixative for the whole sheet. The results of the technical examination of

"La Bella" is consistent with the use of a gum fixative over the original media (supplemented by another layer of sealant, probably gum, applied by the restorer). In short, Leonardo records his intention to enquire about the very techniques that were necessary to create "La Bella Principessa". These are different from the standard procedures of manuscript illumination, which were, of course, well known in Milan.

A complementary note about a wax binder for coloured chalks is found in the second of the Forster Codices (Victoria & Albert Museum, London):

> To make tips [for chalk holders] for dry colouring: [mix] the tempera with a little wax, and it will not rub off, a wax that will dissolve with water, and, having tempered the white, the distilled water will evaporate in steam, and only the wax will remain, and it will make good tips. But you should understand that the colours must be ground on a hot stone.[12]

Another memorandum on the same page is dated Friday, 4 September, which identifies the year as 1495.

It makes sense to see Leonardo making his enquiries—as well as following them up—in advance of the creation of the image. His other references to Perréal also relate better to the earlier date (i.e. 1494, when the French artist was documented in Milan with Charles VIII). In one of Leonardo's typical lists of things to do and to read, and of people to consult, he reminds himself about "the measure of the sun promised to me by maestro Giovanni the Frenchman".[13] This confirms that their shared interests extended beyond matters of art. From internal evidence, the list appears to date from the early 1490s. A further mention of "maestro Giovanni francese" occurs

on one of the anatomical sheets at Windsor,[14] but he does not indicate why he refers to Perréal in this instance. The sheet in question contains studies from *c*.1489, but most of the notes seem to date from a few years later. It is just possible that 1494 was not the first occasion on which they met, but it is probably best to assume that the cluster of references date from the time of Perréal's first documented visit to Milan.

Perréal remains surprisingly elusive as a painter, in spite of his high reputation as a portraitist in the service to three French kings as *valet de chambre*.[15] He was close in age to Leonardo and pursued a career that was no less diverse. He was, as Leonardo testified, involved in astronomy, and he was the author and illustrator of a manuscript poem about alchemy, dedicated to Francis I, in which Nature berates the alchemist for failing to follow her lead.[16] The poet Jean Lemaire de Belges speaks of Perréal's engagement with topography and surveying for civic and military purposes. He was active as a designer of monuments, festivals and ceremonials. We can well imagine that Jean and Leonardo had a great deal to talk about. Lemaire fittingly praises both *maîtres* in his poem *La Plainte du Desiré* in 1509: Leonardo's art is credited with "superlative grace", while we are invited "to see Nature with Jean de Paris".[17] Among the drawings reasonably attributed to Perréal is a portrait in silverpoint of *Louis de Luxembourg, Comte de Ligny* in the Musée Condé, Chantilly (fig. 7),[18] the sitter whom we have already encountered as the intended recipient of Leonardo's well-known memorandum in the *Codice atlantico*. Like other drawings and paintings attributed to the master, it testifies to some skill as a portraitist, yet hardly at a level that matches his contemporary renown.

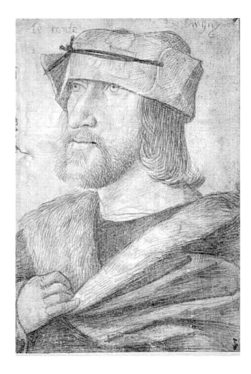

Figure 7

JEAN
PERRÉAL

*Louis de
Luxembourg,
Comte de Ligny*

Chantilly,
Musée Condé

What we do *not* have, however, are any portraits in coloured chalks clearly attributable to Perréal among his known *oeuvre*. Indeed, although French artists are traditionally credited with the invention of the portrait in coloured chalks, surviving examples from the 1480s or 90s are disappointingly scarce. The pioneer of the use of coloured chalks seems to have been Jean Fouquet, as demonstrated by a studio portrait of *"La Belle Agnes"* in the Bibliothèque Nationale de France, representing King Charles VII's famed mistress, Agnès Sorel.[19] A good number of coloured drawings by Jean Clouet are known, but these all date from later decades.[20] There is a portrait of Charles VIII attributed to Jean Bourdichon in the

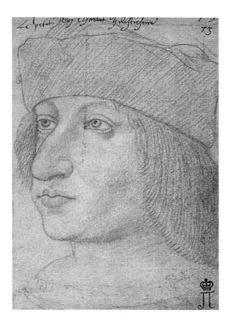

Hermitage, St Petersburg (fig. 8),[21] that uses touches of colour to enliven the drawn image. It may well be that French practice in the late 15th century went no further than such restrained augmentation of the monochrome drawing.

If this is the case, Leonardo characteristically took an existing technique and pushed it much further than his predecessors, colouring the head in a painterly manner to a more extensive degree and adding more continuous layers of colours to create the red and green draperies. In effect, he was inventing a personal kind of coloured chalk drawing, which achieved something of the effect of manuscript illumination.

Compared to the scarcity of French coloured drawings in the 1490s, there is plentiful evidence that Milanese artists adopted the practice of drawing with various combinations of

coloured chalks.[22] Most notable is the meltingly beautiful, if battered drawing of the *Head of Christ* in the Brera, Milan (fig. 9), obviously drawn wholly or largely by a right-handed artist, very possibly Giovanni Antonio Boltraffio.[23] It may be that the draughtsman adopted the medium on his own account in his rendering of Christ, clearly related to the figure in Leonardo's *Last Supper*, though it is not based directly on the painted head (which is bearded); the artist is more likely to have followed Leonardo's own lead, taking inspiration from a coloured drawing by the master himself. This would mean that

Figure 9

GIOVANNI
ANTONIO
BOLTRAFFIO
(?)

Head of Christ

Milan,
Pinacoteca
di Brera

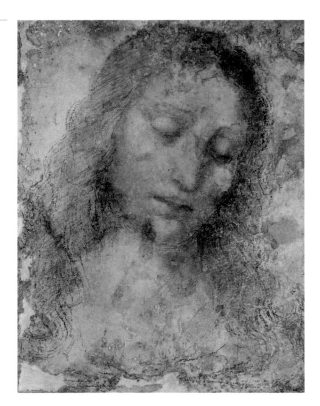

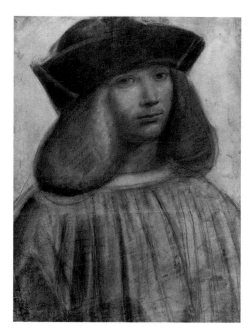

Leonardo experimented with coloured drawings around 1497 in preparation for painting.

Coloured chalks were certainly used for portraiture by Leonardo's followers. Perhaps the earliest example is another sheet reasonably attributed to Boltraffio, this one in the Ambrosiana, Milan, depicting a young man with carefully groomed hair and a large hat (fig. 10).[24] This, too, appears to originate from before 1500. For his drawing of a *Young Man with a Turban* in the Albertina, Vienna (fig. 11), Andrea Solario used a mixed medium close to Leonardo's in *"La Bella Principessa"*, with similar precision of contour.[25] Subsequently, Bernardino Luini was conspicuous among the Lombard artists who adopted the medium for portraits, as in his pretty draw-

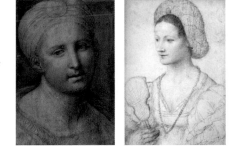

Figure 11

ANDREA
SOLARIO

*Young Man in a
Turban*

Vienna,
Albertina

Figure 12

BERNARDINO
LUINI

*Young Woman
with a Fan*

Vienna,
Albertina

ing of a woman, also in the Albertina (fig. 12).[26] However, none of the followers, with the partial exception of Solario, emulated Leonardo's special combination of linear exactitude with delicate softness. They generally went for broader effects.

The most striking exception is a *Profile Portrait of a Woman in a Hat* in the Louvre (fig. 13), the attribution of which is

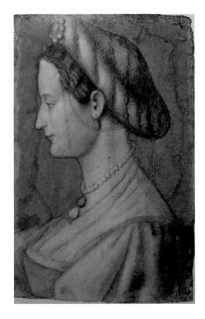

Figure 13

LOMBARD
ARTIST (?)

*Profile Portrait of
a Woman in a Hat*

Paris, Musée
du Louvre

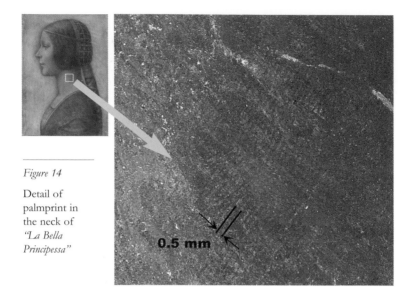

Figure 14

Detail of palmprint in the neck of *"La Bella Principessa"*

0.5 mm

unclear.[27] Executed in coloured chalks on tinted paper, it depicts a young woman in profile with a necklace of pearls and a tilted bonnet, decorated with a pearl roundel. It bears some relationship to Boltraffio's work and probably dates from around 1500. It may be the drawing that exhibits the closest relationship to *"La Bella"* in form and the handling of the chalks. At 442 x 288 mm, it is also broadly comparable in scale.

That Leonardo was pushing his chalk techniques in a painterly direction is confirmed by the handprint visible in the lady's neck (fig. 14), assuming that it is deliberate and not accidental. His paintings before 1500 show extensive use of the fingers or hand to blend the modelling, particularly in the flesh tones.[28] It generally looks as if the soft, fleshy area of the right edge of his right hand was used for this purpose, while he applied the media with his left hand. While he was not unique

44

in exploiting his fingers and hands in paint or priming layers, he did use the technique in a typically widespread and varied manner. It is likely that more handprints were visible in the flesh of *"La Bella"* before the restoration(s). In any event, the print that survives plays a very similar role in his technique to the many handprints in the *Cecilia Gallerani*, as detected by Pascal Cotte and Paul Biro (see pp. 164–8).

In summary, looking over the surviving evidence relating to Leonardo's relationship with Perréal, his use of coloured chalks and its adoption by his followers, it makes best sense to see the Italian master conducting his enquiries of his French counterpart in advance of his executing the image, that is to say when Jean arrived with Charles VIII in 1494 rather than when he returned to Italy with Louis XII in 1499. Leonardo then characteristically took the technique to another painterly level in what was a one-off image.

It is likely that *"La Bella"* was to remain effectively "buried" in a bound codex, more or less unknown, in the years following the fall of Ludovico Sforza, Duke of Milan, who was driven from the city in 1499. Any connection with Leonardo is likely to have been lost. The wooden panel looks older than the 19th century: either the sheet's excision from the manuscript and mounting occurred a long time ago or an old board was used to give it a desirable air of antiquity.

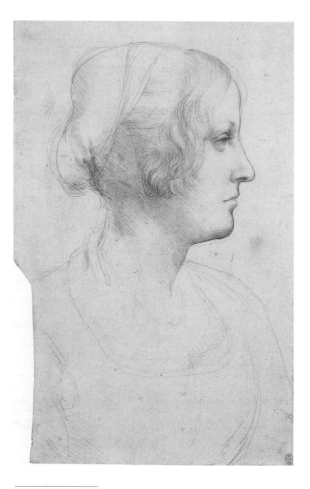

Figure 15

LEONARDO
DA VINCI

*Portrait of a
Woman in Profile*

Windsor Castle,
Royal Library
(inv. no. 12505)

3. Style, Date and Fashion

The most obvious comparison for style and presentation is Leonardo's *Portrait of a Woman in Profile* in the Royal Library at Windsor Castle (fig. 15).[29] Although this is in silver-point on paper, the handling is notably compatible. Most striking is the way that the profiles of the forehead, nose, lips and chin in both have been caressed with insistent, yet delicate strokes of the drawing instruments so that they become firmly defined but retain a nuanced subtlety. Even Boltraffio—the most manually subtle of Leonardo's immediate followers—could not achieve this. The structure of the eyelids, the delicate flicks that create the lashes, and the translucent iris of the eye are extremely close on both portraits, transcending the difference in the media (figs 16 and 17). The Windsor drawing, in which the woman wears her hair and headscarf in a Florentine manner, is likely to date from *c.*1481, unless it portrays a Florentine woman (perhaps a servant) who accompanied Leonardo to Milan around that time.

A superimposition of the two images (fig. 18), with the Windsor study reversed,[30] reveals a notably close correspondence in the way that the proportions of the head and neck are handled, though the features necessarily deviate from that norm to convey a sense of individuality.[31] Pascal Cotte has

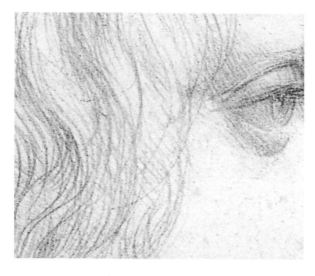

Figure 16

Detail of eye
in figure 15

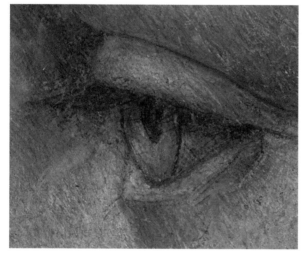

Figure 17

Detail of eye
of *"La Bella
Principessa"*

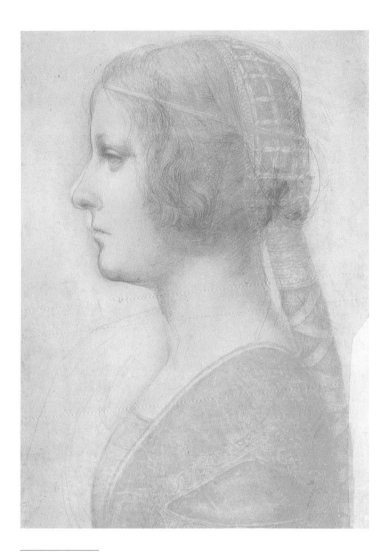

Figure 18

Overlay of figure
15 (reversed)
and *"La Bella
Principessa"*

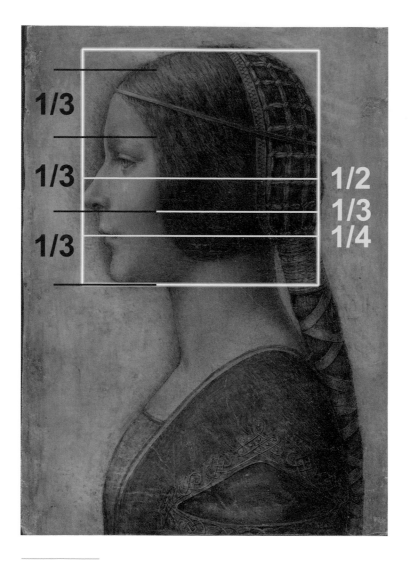

Figure 19

Proportions of
the head of *"La
Bella Principessa"*

50

observed that the proportions correspond closely to one of Leonardo's favoured norms. The artist clearly has in mind a certain ideal, of a broadly classicising kind, which determines how he lays down the basis for the profile (fig. 19). This quest may also, as Cotte suggested, explain the changes he made to the contour of the back of the head (see fig. 70). A considerable amount of space in Leonardo's notebooks was occupied by investigations of the series of harmonic proportions that he believed characterized the internal relationships of the human body (fig. 20):[32]

> *The space from the mouth to below the chin, CD, will be a quarter part of the face, and similar to the width of the mouth.*
>
> *The space between the chin and below the base of the nose, EF, will be a third part of the face, and similar to the nose and the forehead.*
>
> *The space between the midpoint of the nose and below the chin, GH, will be half the face.*
>
> *The space between the upper origin of the nose, where the eyebrows arise, IK, to below the chin will be two-thirds of the face.*[33]

Figure 20

LEONARDO DA VINCI

Proportions of the Face in Profile

Windsor Castle, Royal Library (inv. no. 12304r: detail)

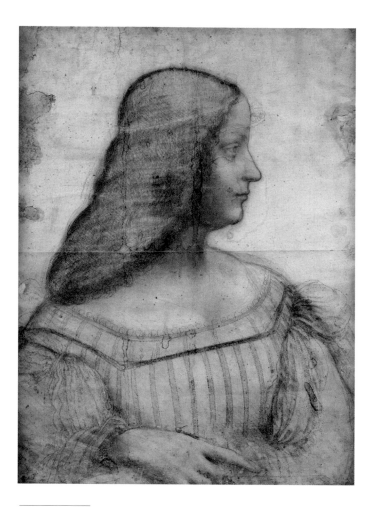

Figure 26

LEONARDO
DA VINCI

Portrait of
Isabella d'Este

Paris, Musée
du Louvre

54

as finally realized, the profile of the sitter conforms to that Florentine ideal in a more explicit manner than that of the Windsor woman, perhaps as befitting her higher station.

The other direct comparison—thus effectively framing the range of possible dates for the present, newly discovered portrait—is the image of Isabella d'Este in the Louvre (fig. 26),[37] undertaken when Leonardo was in Mantua in 1500. The same points about the treatment of the contours of the facial profile and eye can be made with equal force about the Isabella drawing, which moreover uses some coloured chalks to provide a few additional touches of verisimilitude to the characterization of the sitter, though less extensively than in the Milanese portrait.

Leonardo left one version of his portrait of Isabella with the sitter and took another with him (probably the studio version in the Ashmolean Museum, Oxford).[38] After the former was given away by her husband, Isabella wrote to the painter, asking for a replacement and pressing him to provide one "in colour" (*de colore*), as he had promised, rather than in charcoal or black chalk (*carbono*), as the original had been (either wholly or predominantly).[39] This has usually been interpreted to mean that Leonardo was to provide a painted portrait, but the unusual expression *de colore* may well mean that he promised to supply a drawing more extensively coloured than the Louvre version—of the type we now know through *"La Bella"*. However, Isabella reluctantly recognized that completion of the new portrait was unlikely, since Leonardo would probably not be in Mantua again in the near future.[40]

The present portrait loses nothing in quality comparisons with the autograph drawings of Isabella and the woman in the

Windsor drawing. Indeed, as a highly finished work in its own right, it is more fully pictorial in effect. Looking at it in the original, rather than in even the best digital image, the impression is softer, less stilted in pose, more elusive and more romantic. The transitions of tone in the flesh are beautifully mellifluous, even if affected by some later restoration(s). The hair, although tightly dressed, falls in characteristic Leonardo rivulets, and just a hint of the woman's left ear teases the spectator's enquiring eye. The structural properties of the net headdress or caul reveal his special sense of the "engineering" of such things. We have noted how the thin band that passes from her hairline to the back of her head squeezes the rear contour of the net and how her pigtail swells slightly where it is less tightly constrained. The binding of her pigtail or *coazzone* could almost come from one of his mechanical drawings. The knot designs on the margin of her headdress and over the aperture in her sleeve show Leonardo's well-developed sense of the up-and-over properties of such interlacing, though the restorer has in places obscured the spatial logic of the pattern.

The high formality of her shoulders and bust—a formality exaggerated by the restorations in this area—makes obvious reference to the dignified form of a sculpted portrait bust or more directly to the images on Roman coins. The leading practitioner of the sculpted genre at the Sforza and d'Este courts was Giovanni Cristoforo Romano. He is the author of the superb marble bust in the Louvre of Ludovico il Moro's future bride, Beatrice d'Este,[41] which probably just pre-dates their marriage in 1491. Romano was noted as a medallist and sculptor of relief portraits in profile. His medallic image of Isabella d'Este (fig. 27)[42] was produced in the most extravagant man-

ner possible, in gold and surrounded by diamonds. Leonardo worked in a world that delighted in luxurious and highly formal portraits.

As well as experimenting with unconventional head and body positions in portraiture, Leonardo was fascinated with what could still be conveyed in the traditional profile format. In his *paragone* (the comparison of the arts), he argued that the painter could fully describe every aspect of a form through "two half figures". He was also endlessly engaged with the potential of profiles to convey character. This is manifested in his repeated sketches of epicene youths and in his obsessive drawings of grotesque physiognomies. We will also see that there is an explanation for the left-facing orientation of the

profile when we come to examine the function of the portrait.

The profile portrait was clearly favoured by ruling families in the North Italian courts, and nowhere more so than in Sforza Milan. Historians' tendency to regard the profile as somehow *retardaire* is unwarranted. It was used as demanded by decorum.[43] Indeed, it seems to have been obligatory for the inner circle of Sforza family members and their consorts. The Duke's mistresses, Cecilia Gallerani and Lucrezia Crivelli, could, by contrast, be portrayed in less conventional poses, but the "princesses" warranted the formal profile. That the profile was regarded as appropriate when high dignity was required is evident from the four kneeling members of the Sforza family in the *"Pala Sforzesca"* in the Brera (fig. 28).[44] It also features in other works, such as the portrait of Ludovico's niece Bianca Maria Sforza, now in the National Gallery of Art, Washington DC (fig. 29), which was probably painted by Ambrogio da Predis[45] at the time of her marriage contract in 1493 with the Holy Roman Emperor Maximilian I; in the two panel portraits of Ludovico's wife, Beatrice d'Este; and in the barely legible portraits added to the large fresco of the *Crucifixion* by Giovanni Donato Montorfano opposite Leonardo's *Last Supper* in Sta Maria delle Grazie.[46] In 1502, when Ambrogio signed and dated the portrait of Bianca Maria's husband, *Emperor Maximilian* (Vienna, Kunsthistoriches Museum),[47] the profile was again the favoured format. It is also the mode of portrayal adopted in illustrated genealogical manuscripts.[48]

The presentation of the Sforza ladies, Bianca Maria and Beatrice d'Este, also confirms the high fashionability of extremely long and elaborately bound pigtails in the 1490s. To achieve the required length, a hairpiece was generally added

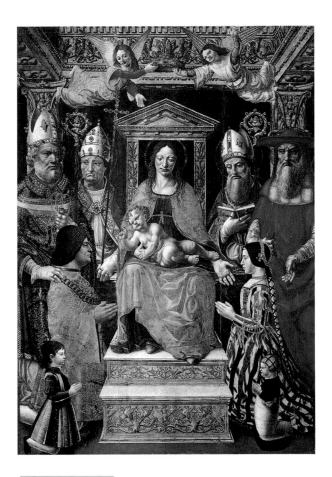

Figure 28

MASTER OF
THE PALA
SFORZESCA

*Madonna and Child
with the Sforza Family
(the "Pala Sforzesca")*

Milan, Pinacoteca
di Brera

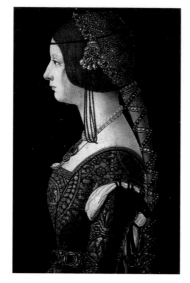

and coloured to match the lady's own hair, which itself might be dyed. The fashion for the *coazzone* seems to have originated in Spain, and Beatrice had probably become enthusiastic about it during her youthful years in Naples, which was governed by the Aragonese.[49] In Milan from 1491 onwards, Beatrice gained a notable reputation as a leader of fashion, and her *coazzone* became a signal feature of Ludovico's court ladies.[50] Their portrayal in profile with the hairstyle apparent in its full glory seems to have become prescribed for the "princesses".

The missal that was compiled for Archbishop Guidantonio Arcimboldi of Milan shows a cluster of kneeling ladies in attendance at the 1494 investiture of Ludovico as Duke of Milan (fig. 30), following the death of his nephew (Bianca Maria's brother), the youthful Gian Galeazzo Sforza.[51] The Duke himself is ensconced in a canopied pew to the left, while

60

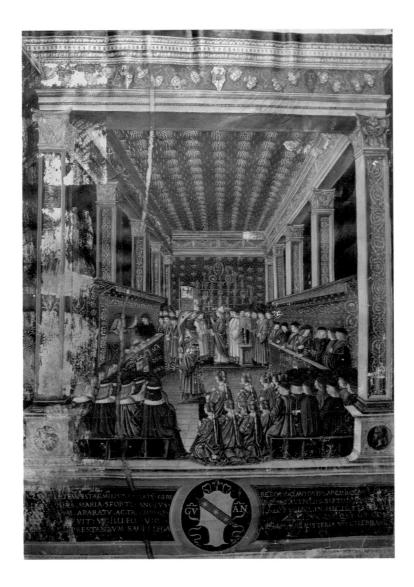

his *gonfalone* is brought towards him. Might the bearer be Galeazzo Sanseverino, commander of his forces? Eight of the ladies prominently display the *coazzone*, and the caps of at least five others suggest that they have also followed the protocol.[52] The facial types of the *coazzone* corps are varied to some extent, but unfortunately not sufficiently to allow them to be individually identified. Indeed, on this small scale, Ludovico himself is recognizable by position, size and hairstyle rather than by detailed likeness.

The two independent paintings of Beatrice d'Este, one in Christ Church, Oxford (fig. 31),[53] and the other in the Uffizi, Florence,[54] were probably generated at the time of her marriage to Ludovico il Moro in 1491.[55] The survival of closely related versions is not surprising. It is likely that other portraits of ruling families in the North Italian courts were produced in more than one version.[56] Apart from some minor details in the costume and a few strands of hair falling loosely from her coiffure in the Uffizi version, they are very similar. The Christ Church portrait, which was once overpainted as a figure of St Catherine, seems to be of slightly better quality.[57] Beatrice's *coazzone* is bound in a complex manner with intersecting spirals. Her jewellery includes two very grand pearls, one of which is tucked into the neckline of her dress, while the other hangs free over her left ear. We know that at least one of the pieces was sent by Ludovico to his wife-to-be in August 1490. It was described as "a beautiful necklace with large pearls strung on gold flowers and a beautiful jewel fastened to the said necklace, in which there is a very beautiful emerald of great presence, and a ruby and a pearl in the shape of a pear".[58] Such items of lavish jewellery were notably expensive,

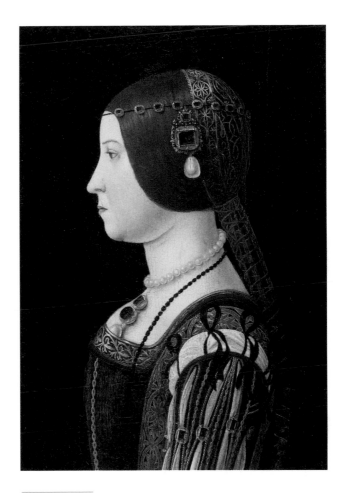

Figure 31

AMBROGIO
DA PREDIS (?)

*Portrait of
Beatrice d'Este*

Oxford, Christ
Church Picture
Gallery

costing as much as, if not more than, a painted altarpiece by a leading master. The way the necklace in the portrait is strung is not evident, but in other respects it matches the one that was sent from Milan. It may be that the comparable jewel hanging from her hairband was also a gift from Ludovico, and was matched by one on the right side of her head. The colours— green, red and white—were contrived to match to the Sforza livery. A comparable necklace had obviously been made up for Bianca Maria, as can be seen in her portrait (see fig. 29).

On his visit to the Milanese court in 1494, Charles VIII was so impressed by the style of the Milanese ladies, led by the fashion-conscious Beatrice, that he ordered or acquired a portrait of the Duchess to send to his sister, Anne, Duchess of Bourbon. A member of Charles's entourage reported to Anne on the effect that Beatrice had on the king.

First of all, when she arrived she was on a horse with trappings of gold and crimson velvet, and she herself wore a robe of gold and green brocade, and a fine linen "gorgette" turned back over it, and her head was richly adorned with pearls, and her hair hung down behind in one long coil with a silk ribbon twisted round it. She wore a crimson silk hat, made very much like our own, with five or six red and grey feathers, and with all that on her head, sat up on horseback as straight as if she had been a man. And with her came the wife of Seigneur Galeazzo [Bianca Sanseverino, daughter of Ludovico Sforza] *and many other ladies, as many as twenty-two, all riding handsome and richly apparelled horses, and six chariots hung with cloth of gold and green velvet, all full of ladies.... The next day, after dinner, he went to see this lady, whom he found magnificently arrayed, after the fashion of the country, in a green satin robe.*

The bodice of her gown was loaded with diamonds, pearls, and rubies, both in front and behind, and the sleeves were made very tight and slashed so as to show the white chemise underneath, and tied up with a wide grey silk ribbon, which hung almost down to the ground. Her throat was bare and adorned with a necklace of very large pearls, with a ruby as big as your "Grand Valloy," and her head was dressed just the same as yesterday, only that instead of a hat she wore a velvet cap with an aigrette of feathers fastened with a clasp made of two rubies, a diamond, and a pear-shaped pearl, like your own, only larger If the king were not going to send you her picture, to show you the fashion of her dress, I would have endeavoured to obtain one to send you myself.[59]

Unfortunately, the portrait, probably executed for Charles by Perréal, does not survive. Was it on paper or vellum for ease of transport? We can be sure that the hairstyle was duly recorded. The *coazzone* was sometimes adopted by aristocratic women outside the immediate Milanese context, but nowhere else was it adopted on such a scale as a courtly uniform.

When set beside the pearl- and gem-festooned creations worn by Bianca Maria and Beatrice, the hair of *"La Bella"* is finely and formally dressed, but relatively modest in its materials. Surprisingly, she has no jewellery. And her dress, with its simple triangular aperture, has none of the knotted ties that adorn the costumes of the two other Sforza ladies. Leonardo has consciously simplified the costume and accoutrements, compared to the other court portraits, possibly because the context was one in which less ostentation was fitting.

Ambrogio da Predis's portrayals of Bianca Maria and Beatrice may exceed Leonardo's in lavishness, but Ambrogio's

presentation of the headdresses is unperceptive, though it is skilled at a certain level. There is none of the sense of the plastic reality of the materials that characterizes Leonardo's rendering. Not least, the thin bands that help retain the cauls in position on the back of the sitters' heads in Ambrogio's paintings make no impression on the rear contour of the nets, and the silhouettes of the *coazzoni* are tediously regular.

The other painted portrait that bears a close relationship to *"La Bella"* is the *Profile Portrait of a Woman* in the Ambrosiana, Milan (fig. 32).[60] The coiffure of the unknown sitter is similar, though again more lavish with its pearl adornments. The subtlety of the profile is greater than was the norm with Leonardo's followers, and the loops of the ribbon that hold the net in place are beautifully characterized. The pearls fringing her headdress catch the light quite differently against the backdrops of her hair and skin, in a notably subtle manner. However, the general execution lacks Leonardo's uncanny vitality. Again, the retaining ribbon sits on top of the net without affecting its contours. By contrast, in the so-called *"La Belle Ferronière"* in the Louvre, which is wholly or largely by Leonardo himself (see fig. 23), the tightly bound hair visibly responds to the constriction of the horizontal band.[61] Leonardo cared about such physical details to a degree that few artists have equalled.

The attribution of the Ambrosiana portrait remains a puzzle. If, as will be suggested, the sitter is Anna Sforza, another of Ludovico's nieces, the author might be an accomplished painter working outside Milan (e.g. Lorenzo Costa) in the years following her marriage in 1491 to Alfonso d'Este, Duke of Ferrara. This would explain why it does not fit convincingly

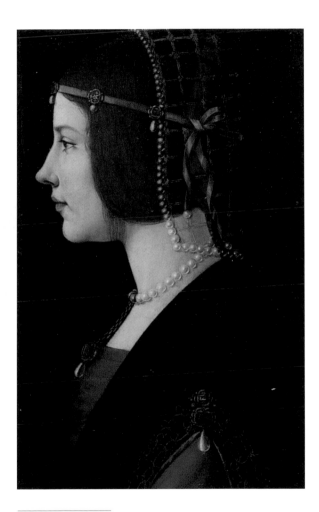

Figure 32

UNKNOWN
ARTIST

*Portrait Portrait of a
Woman (Anna Sforza?)*

Milan, Biblioteca
Ambrosiana

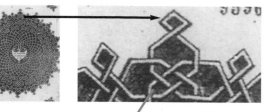

d'Este's *divisa* of the *fantasia de' vinci* was "invented" by the court poet Niccolò da Correggio in 1492. The *vinci* on which Niccolò exercised his *fantasia* ("imaginative invention") were the flexible osiers (*vincoli*) that could be used in weaving baskets and decorative items. Like the gold thread that is interlaced with tree branches in Leonardo's *Sala delle Asse* in the Castello Sforzesco,[65] the motif of the *vinci* signifies intertwined unity of the kind that binds lovers together, as well as punning on *vincere* ("to triumph over"). On 12 November 1493, Beatrice sought her sister's permission to use the motif:

> *I cannot remember if your Highness has yet carried out the idea of that pattern of linked tracery which Messer Niccolò da Correggio suggested to you when we were last together. If you have not yet ordered the execution of this design, I am thinking of having his invention carried out in massive gold, on a camora of purple velvet, to wear on the day of Madonna Bianca's wedding.*[66]

Isabella responded that she had not yet used it herself and was happy for her sister to do so. After its debut at the wedding of Bianca Maria to the emperor in 1494, the *fantasia dei vinci* entered the more general currency of court fashion in Milan.

Given the way that the *fantasia* chimed with Leonardo's own name, it is not surprising that when he designed a "logo" for his "Academy", he adopted the interlace, creating a virtuoso design around a medallic inscription (figs 34 and 37).[67] The knots served to signify formally, symbolically and socially his ambitions for himself and his revered "science" of *disegno*. It functioned as a suitable emblem for an informal assembly of intellectual exchange with valued colleagues.

stained vellum, remarkably bound in copper.[72] The vellum
copy apparently destined for Bianca Maria (now in the Öster-
reichische Nationalbibliothek, Vienna) was bound in black vel-
vet with gold decorations and dates from after Beatrice's death
in 1497.[73] A third, less formal manuscript compilation of the
Visconti poems (which is also in the Biblioteca Trivulziana) is
on paper and contains dedicatory notes to both Beatrice and
Bianca Maria.[74]

The dedicatory poem to Bianca Maria, whom Visconti had
accompanied on her transalpine journey to join her husband,
sets the tone:

When my glorious Duchess [Beatrice]*, or rather my Mistress,*
Or rather my Numen [divine spirit]*, was still alive,*
Since she really appreciated my style,
Oft-times I fell into the habit of writing poems.
However, after bitter death dragged her away,
The water of my customary river dried up
And my fantasy [fantasia] *became so ruptured and confounded*
That my mind [ingegno] *strove to create in vain.*

Now that Your Majesty [Bianca Maria] *commands me*
To send you some new piece,
I send a small book
That I had already dedicated to her:
Very little more than this is left inside me;
I beg you to accept it,
From myself, your faithful servant,
For you are seldom out of my memory.
And to serve you, my always august queen,
Makes me feel more valued,

74

For I know that the Duke appreciates my serving you.[75]

The subsequent *canzoniere* extol the delights and ordeals of love, the vagaries of fortune, the joy that comes from heaven and the radiant wonders of beloved ladies, not least their captivating eyes. Replete with classical allusions to Venus, Mars, Phoebus and a cast of mythological characters, Visconti's poems play seemingly endless variations on the standard tropes of Italian Renaissance love poetry.

A presentation volume of this type was a luxury item of the first order, produced by the very best craftsmen with the finest materials as a treasured memento of a great event or as an act of homage from the court poet to an esteemed female patron. The known surviving examples probably represent but a minor proportion of those generated at the North Italian courts. The Visconti codices on vellum were relatively small, at 142 x 96 and 198 x 135 mm respectively, but the less formal version on paper, at 315 x 239 mm, is similar in dimensions to the portrait. If the Leonardo portrait was part of a presentation volume, it stood at the upper end of the scale for such a production. A portrait of the "beloved lady" would make a suitable frontispiece or main illumination for a set of verses, just as in the early 14th century Simone Martini had portrayed Petrarch's beloved Laura in his prized Virgil manuscript.

Leonardo's painted portraits of both Cecilia Gallerani and Lucrezia Crivelli, successive mistresses of Ludovico, were themselves subjects of laudatory verses in the Petrarchan and classical modes.[76] That for Cecilia, written by Leonardo's fellow Tuscan, Bellincioni, is cast in the form of a dialogue between the poet and discomforted Nature:

Leonardo is exploiting the well-known literary form of a dialogue, just as he is alluding in a learned manner to the ancient dictum of Simonides that painting is mute poetry, and poetry is blind painting.

If we are right in thinking that the portrait was specifically produced for a bound set of poems, the senses of sight and hearing are both nourished in one product. A close later parallel is provided by the luxury manuscript in the British Library containing verses by Pierre Sala, the poet of Lyon, in honour of his beloved (and future wife), Marguerite Builloud.[80] The manuscript climaxes with a portrait of the poet himself (fig. 39), which was painted by none less than Jean Perréal. On the page facing the poet's portrait, Perréal has overtly imitated Leonardo's left-handed mirror-writing. The hypothetical manuscript setting of the portrait of the lady in a similar set-up, facing a poetic inscription, would explain its orientation to the left. Leonardo's intention to enquire from Perréal about how to extract the maximum number of double sheets from a

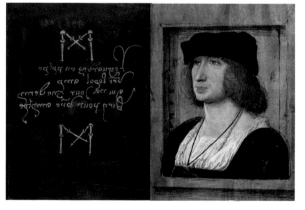

Figure 39

JEAN PERRÉAL

Portrait of Pierre Sala

London, British Library, MS. Stowe, 955

stretched and prepared skin might mean that he was in overall charge of the assembling of the volume in honour of the young lady. The collaboration with artist and poet would thus have been similar to that in the making of the Sala codex.

We can propose, therefore, a working model for the kind of setting in which the portrait made its debut. But can we go further, and suggest a possible sitter? In view of the highly specific applications of the profile format and *coazzone*, there are really only five prominent possibilities: Ludovico's wife Beatrice, Isabella of Aragon (the wife of his nephew Gian Galeazzo), his nieces Bianca Maria and Anna, and his illegitimate daughter Bianca. Of this quintet, the first three can effectively be ruled out, since we know what they looked like.[81] There is no certified likeness of Anna, Alfonso d'Este's youthful bride, and she remains a possible candidate for *"La Bella"*.

The fifth possibility stands out, however. In October 1489 Ludovico took legal steps to legitimize Bianca, the daughter of his mistress Bernardina de Corradis.[82] The next year Bianca was betrothed to Galeazzo Sanseverino, the favoured commander of Ludovico's armies. They were to be formally conjoined in marriage in 1496, when Bianca was some 13 to 14 years old. Galeazzo was a major figure at the court, a close confidant of the Duke, and a patron of Leonardo. He warrants a study as a patron in his own right. Galeazzo's stables, attached to his new palace in the park next to the Castello, provided horses that Leonardo measured in his quest to complete the equestrian memorial to Francesco Sforza.[83] Leonardo also directed at least one *festa* in Galeazzo's palace, to accompany a joust in 1491, probably as part of the double Sforza–d'Este wedding celebrations of Ludovico to Beatrice and Anna

who was subject to poetic adulation, early marriage and, on at least four sad occasions, early death. Bianca, Anna, Bianca Maria and Beatrice were all to die young. The portrait on vellum effectively inscribes the lady's aristocratic destiny as a young bride no less surely than the adoring poet's lines in fine calligraphy portray the circumscribed roles of the courtly ladies.

The lady in profile is an important addition to Leonardo's canon. It shows him utilizing a medium that has not previously been observed in his *oeuvre*, but one that relates closely to his interest in the French artist Jan Perréal. It testifies to his spectacular exploration and development of novel media, tackling each commission as a fresh technical and aesthetic challenge. It enriches our insights into his role at the Milanese court, most notably his depiction of the Sforza "ladies"—whether family members or mistresses. Above all, it is a work of extraordinary beauty.

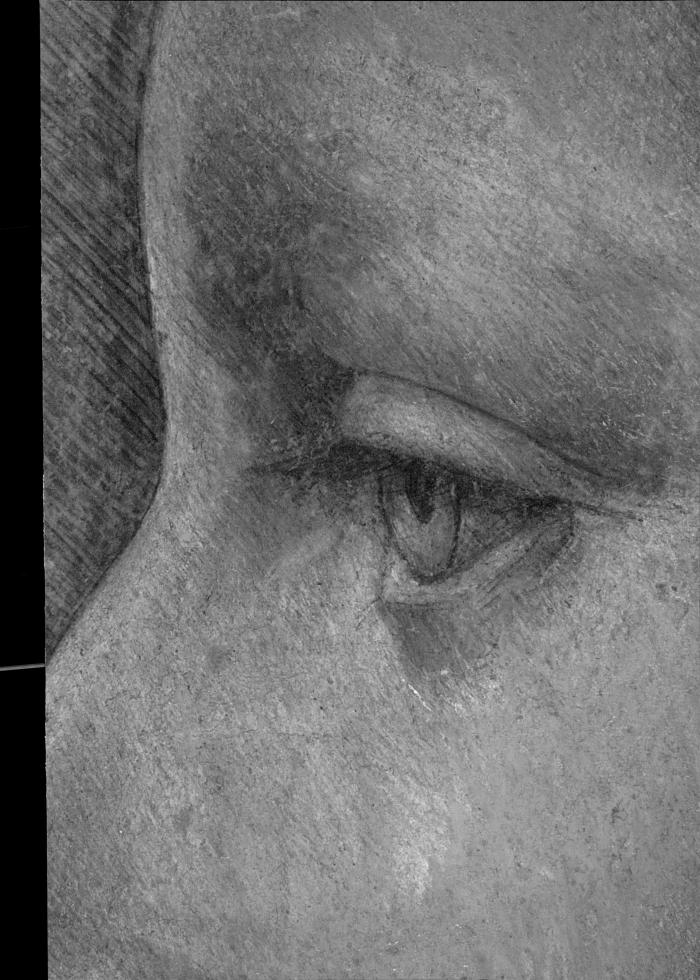

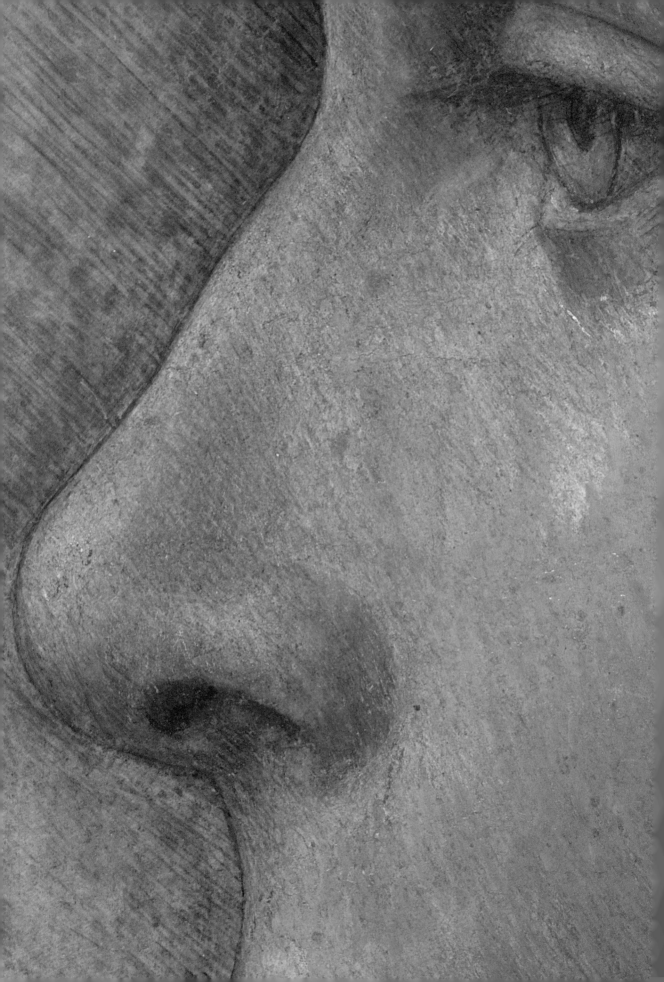

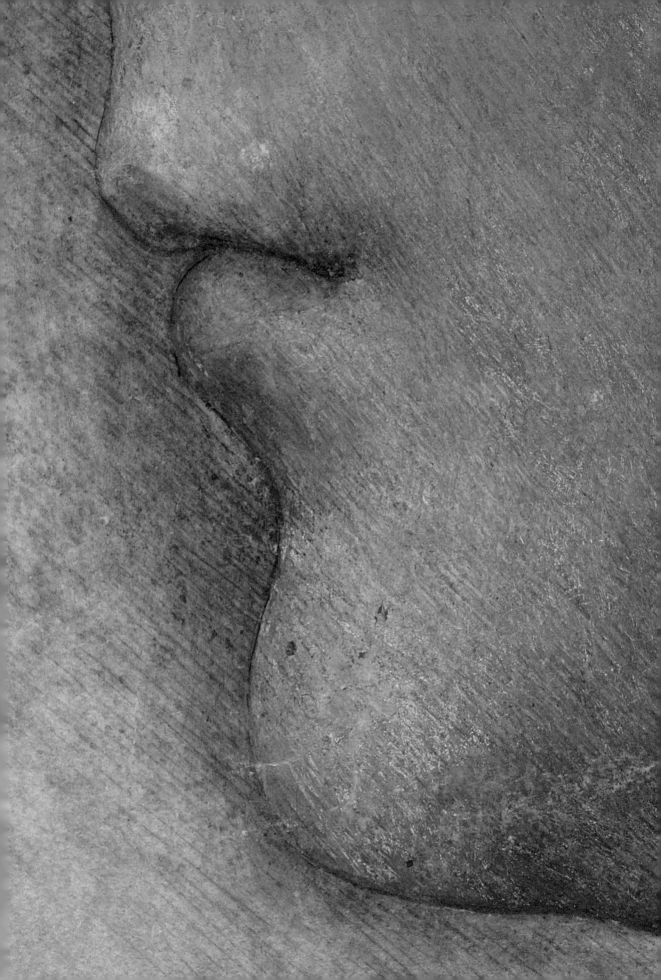

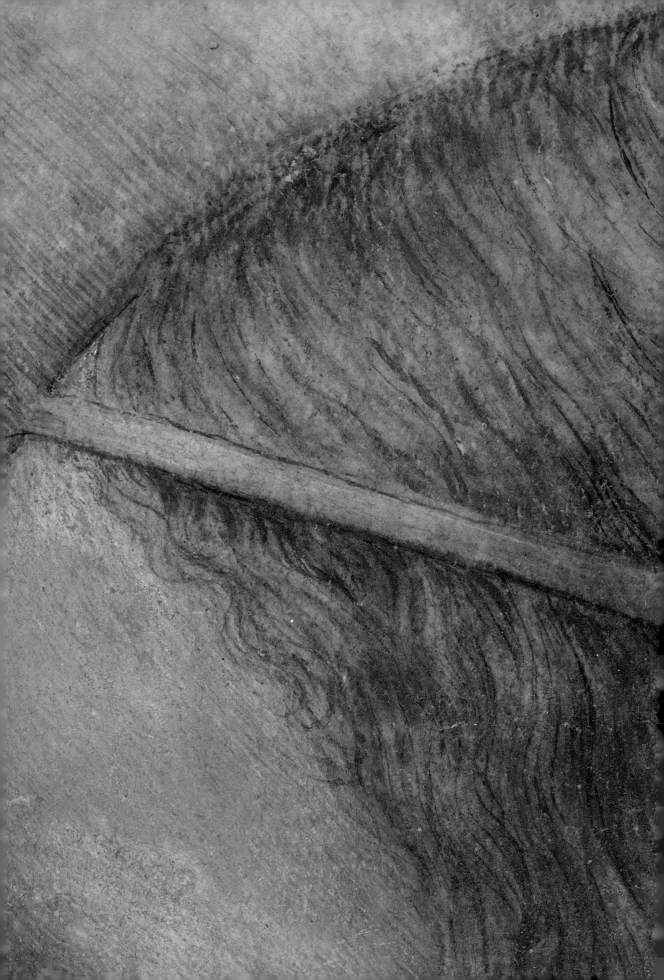

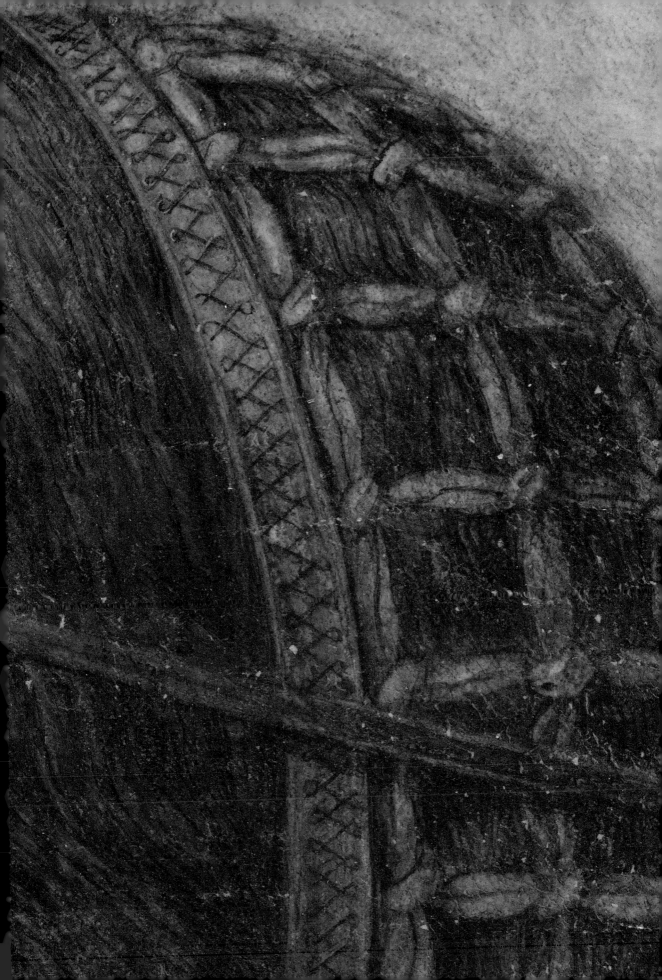

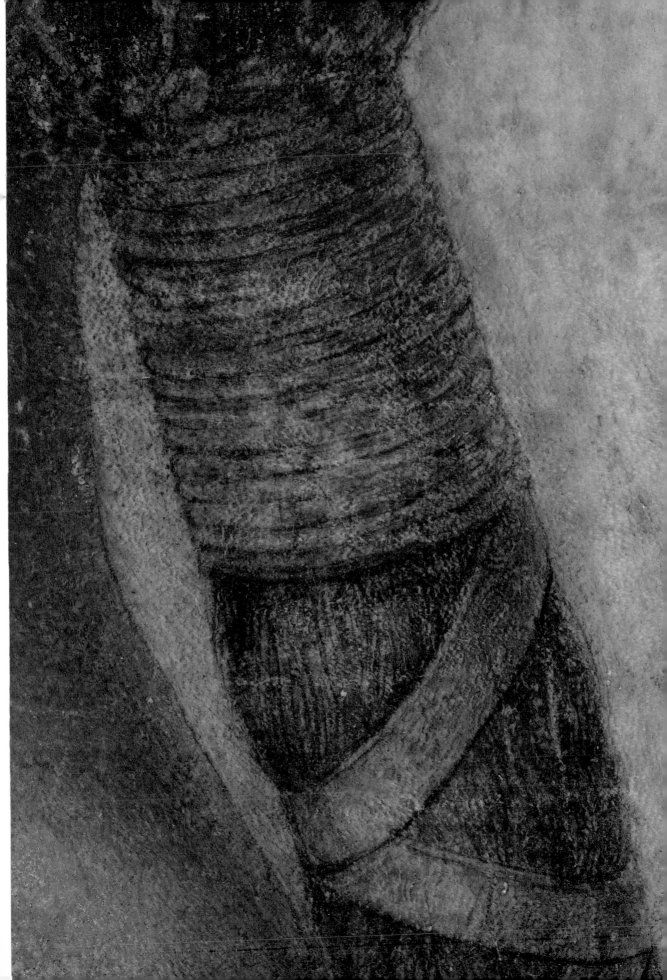

1. Introduction

MARTIN KEMP

The bodies of evidence presented in Part I of this book centred on the art-historical issues of style, dating, medium, function, meaning, patronage and sitter. We have already encountered, mainly in summary, some of the evidence from the intensive technical examination provided by Pascal Cotte, with special assistance from Paul Biro, who is an expert on artists' fingerprints. It is now time to unveil the full extent of Cotte's findings, presented as an integral part of the process of research on which this book is founded. In art-historical literature, such findings typically appear as adjuncts or appendices to the main text. Here they are given their full due. There are, necessarily, technical explanations that involve some specialist terms, but we have endeavoured to handle them in such a way that the non-specialist can follow the arguments.

We are also documenting the evidence about the restoration of the portrait in greater detail than is customary. For someone unfamiliar with the technical evidence about the restorations of works by Old Masters, it may appear that the image of the Milanese "princess" has been substantially modified over the years. In fact, the extent of the restoration(s),

given the support and the medium, is unremarkable for a work that is over 500 years old. A number of Leonardo drawings have been "reinforced" by retouching over the years, a process that began in his own studio. His best-educated pupil, Francesco Melzi, heir to his drawings and manuscripts, strengthened some faded or rubbed outlines and modelling in the drawings now held in the Royal Library at Windsor.[91] Looked at with the naked eye, rather than greatly magnified in high-resolution images, the "reinforcements" made by the restorer(s) of *"La Bella Principessa"* work tolerably well, with the exception of the costume, and do little to diminish the thrilling visual effect exercised by Leonardo's own unrivalled handiwork. In short, we are seeing a Leonardo, not something that has been visually compromised to a significant degree.

At the end of the book, following the journey of discovery that will be successively documented in Part II, I will provide a compact conclusion.

2. *Multispectral Imaging*

PASCAL COTTE

When the owner of what we are now calling *"La Bella Principessa"* brought it to Lumière Technology to be scanned using our innovative multispectral imaging system—a camera system that produces a series of digitized images of unprecedented resolution and colour accuracy, each in a different spectral band (channel)—all we knew was that it had been sold as by an anonymous 19th-century German artist. Although completely unaware of its possible attribution to Leonardo da Vinci, it immediately occurred to us that it would benefit from a detailed scientific investigation carried out using the same methods we had previously applied to Leonardo's *Mona Lisa* and his *Cecilia Gallerani*.

The Lumière multispectral camera system

Lumière Technology has been developing cameras for capturing digital images of archival material since 1998, when the company registered its first of two patents for high-resolution devices for digitizing large-format documents.[92] The main technical challenge of earlier multispectral imaging systems was not the camera itself but the lighting method it required. As previously manufactured, such cameras needed a level of light that was generally incompatible with the size and fragili-

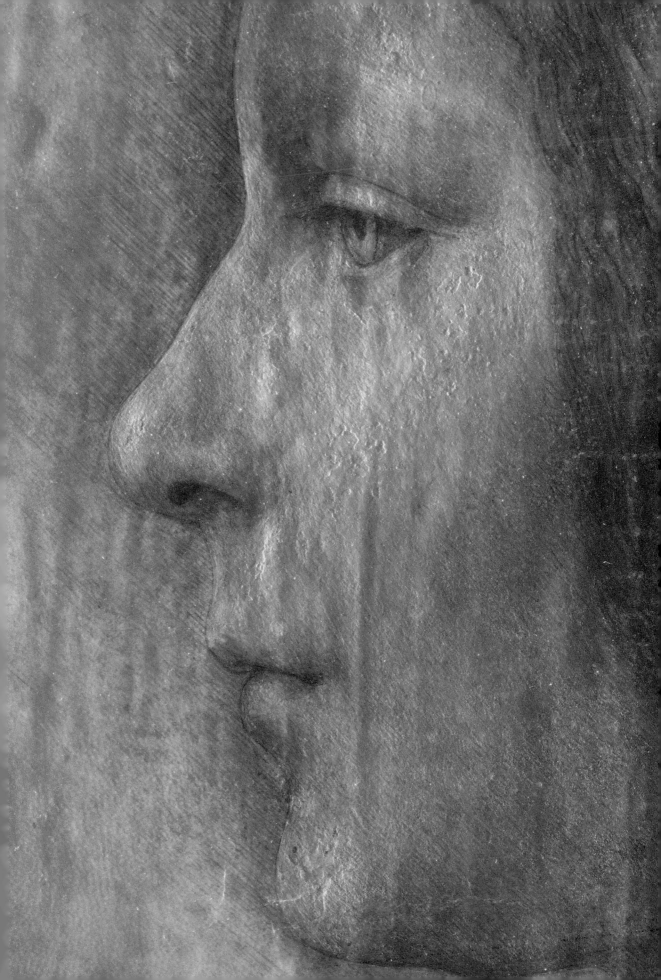

ty of two-dimensional artworks. To illuminate a canvas of 4 x 3 m (12 m²) using traditional methods, for example, it required 130,000 watts of power! Lumière Technology's patented system resolved this problem with a dedicated lighting apparatus that concentrates the light only where it is needed to capture the image, without compromising the overall integrity of the work.[93] With this system, which requires only 2400 watts of power, the painting absorbs very little light energy (in fact, less than 50 lux/hour, which is the generally accepted level for the exhibition of drawings).

In April 2000 the European-financed CRISATEL project endorsed the use of our multispectral camera and its lighting system for the archiving and digitization of pictorial heritage. Between the digitization of the *Mona Lisa* in October 2004 (see fig. 2), followed by the *Cecilia Gallerani* in September 2006, we began to manufacture our camera system. It has since been used in public and private collections around the world, including the Van Gogh Museum in Amsterdam, the Kroller-Muller Museum in Otterlo, the Musée des Beaux-Arts de Lille, the Art Institute of Chicago, the Cleveland Museum of Art and the Czartoryski Museum in Kraków.

How multispectral imaging works

Colour is a visual phenomenon that results from rays of light (i.e. electromagnetic radiation) being absorbed, reflected or refracted from the surface of an object. Because the amount of radiation emitted differs from one luminous source to another, colours are perceived differently: an object does not yield the same colours in daylight, for example, as when seen under a tungsten lamp or a neon light. It does not have "one"

scale of colours, but an infinite gamut.

To understand and document this phenomenon in terms of a painting or drawing, we need to reconstruct the spectral reflectance curves of the mixture of pigments that make up its pictorial surface. This is exactly the process that occurs when the multispectral camera uses 13 different filters to gauge the reflected light on the various layers of the painting. By then processing the spectral reflectance data of each of some 240 million pixel points individually, regardless of the kind of illumination, we can calculate very precisely how each colour is perceived by the human eye.[94] One can subsequently go on to simulate digitally how the painting would look under any light condition.[95]

This technique is a revolution in the history of photography, for it resolves a problem that has plagued the discipline for more than a century: accurate or true colour. For each pixel, we now have an exact scientific measure. In traditional photography (whether digital or gelatin silver), colour data was restricted by two factors: first, by the conventional RGB (red-green-blue) system of primary colours used to record the impression and, second, by the light sources used. A photographer in New York does not have the same light available to him as his colleague in Madrid or Paris; therefore their photographs are not scientifically comparable.

The advantages of multispectral scanning and analysis do not end there: the system allows us to examine aspects of the work that are invisible to the naked eye. The surface is scanned under near ultraviolet (NUV) light (whose wavelengths are too short for the human eye to see) and, at the other end of the electromagnetic spectrum, at not one, but three levels of near

infrared (NIR) light (whose wavelengths are longer than those of visible light). In each case, we maintain the same definition, providing useful extra information on the artwork. The reconstruction of the spectra in broad wavebands enables pigments and mixtures to be identified in a non-destructive manner (i.e. without taking samples).

Finally, because Lumière's multispectral camera is synchronized with an innovative lighting system—in which the light is concentrated by an elliptical mirror and projected as a line that scans the surface—spatial homogeneity of illumination is maintained while the total amount of light to which the work is exposed is minimal.

The digitization of *"La Bella Principessa"*

Let us look at how this multispectral technology can be applied to the digitization of a work of art, specifically to the portrait of *"La Bella Principessa"*.

The portrait was digitized at a resolution of 1008 dpi, giving an extraordinary definition of 1570 pixels per mm^2! To put this in context, a conventional professional camera, depending on the model, is capable of recording no more than 100 pixels/mm^2. Each pixel measures only 25 microns. At this new level of resolution, the slightest nuances and tiniest details— the finest or deepest craquelure, the grainy surface texture of chalk or graphite, even fingerprints—are perfectly visible. The depth of field is greater than 2 mm.

In a single scanning session, which lasted only an hour, the work was measured and captured in 13 spectral bands (fig. 40), during which the multispectral camera recorded and generated approximately 24 Gb of digital data:[96]

100

Figure 40

The 13 multi-
spectral images
of *"La Bella
Principessa"*, plus
reconstructed
scans in false-
colour infrared
and daylight

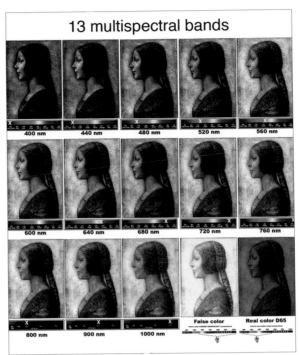

- One image in near UV (with wavelength range of 380 to 420 nm)
- Nine images in visible light (440 to 760 nm, with increments of 40 nm)
- Three images in near infrared light (at 800, 900 and 1000 nm, with increments of 100 nm)
- One infrared image in raking light
- One panchromatic image in raking light

From this data, a further ten computer-generated images are usually created automatically (fig. 41), the nature of which will be explained in the following pages. These include:

101

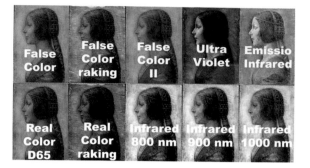

Figure 41

Ten further images of *"La Bella Principessa"* generated with multispectral imaging system software

- One false-colour infrared image ("type I" extended to a wavelength of 1050 nm)
- One false-colour infrared image ("type I") in raking light
- One false-colour reversed infrared image ("type II" with blue-cut filter/IR 1050 nm)
- One infrared emission
- One real-colour image in daylight (D65: overcast daylight 6500°K)
- One real-colour D65 image in raking light
- One simulated image of the work with its varnish removed (this was not applicable to *"La Bella Principessa"*)
- One restoration map (see fig. 75 below)

Combining both these data sets, a completely new digital image is built up, at a resolution of 240,000,000 true pixels and covering the entire light spectrum, in other words, at the very limit of the physical laws of optics (fig. 42).[97]

Infrared images

For years, infrared photographs and reflectograms have been used in the study of paintings, initially in the form of silver gelatin prints, later as digital images onscreen. Their purpose

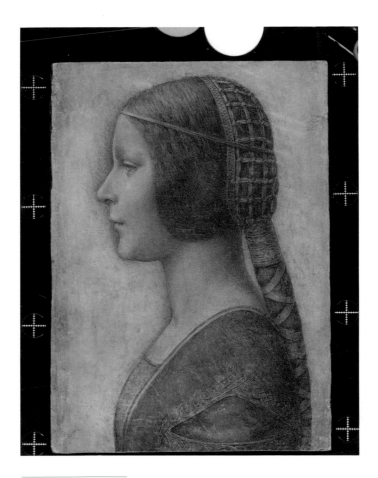

Figure 42

Final digitized multi-spectral image of *"La Bella Principessa"*. Crosses on the sides enable the data from the 13 scans to be aligned. The semicircular disc at top is a Spectralon® reflectance standard

was to produce an "image" that contained additional information, namely what could be seen beneath the various paint layers, since many pigments that are opaque to ordinary visible light are transparent to infrared. High definition was not considered important for this type of image, and a single infrared capture (at a standard wavelength) usually sufficed. Unlike these photographs, multispectral infrared images have five advantages:

- There is not one, but three infrareds generated, captured at three different wavelengths.
- This provides images at three different depths below the pictorial surface.
- One can calculate the differences between the three infrareds (see infrared emission below).
- The infrareds are standardized across the entire surface, which means the degree of transparency of the pigments to infrared light can be measured and the pigments identified.
- The high resolution allows the tiniest details of the underlayer to be revealed (such as underdrawings), and since the measurements are standardized, detailed scientific comparisons can be carried out with other paintings, with the tangential benefits for the identification of authorship and the study of restoration campaigns.

Raking light infrared images

Raking light is indispensable for the study of the surface relief and the structure of the pigment layer, but capturing an infrared image in raking light is even more useful, since it reveals the texture and character of restorations, as well as

areas of retouching. This new type of image became possible only with the development of multispectral imaging, significantly augmenting the arsenal of investigative tools available to study the physical structure of paintings and drawings.

False-colour infrared images

Human vision can detect the range of the light spectrum only from blue to red, from about 400 nm (violet) to 750 nm (red). An image in "false-colour" (e.g. fig. 43) allows the eye to "see" wavelengths that are normally invisible, such as infrared (over 750 nm), but in terms of colour. It simulates human vision extended to infrared wavelengths. The term "false-colour" has long been used by Kodak to describe two types of special infrared-sensitive colour transparency film (I and II), which transform or reverse the colours. Unfortunately, these photographs tended to be very blurred and the colours imprecise.

Infrared emission images

The term "infrared emission" is used by analogy with the term "X-ray emission"; it allows details to be seen under materials with little or no optical transparency. Infrareds penetrate the pictorial layer of the painting, which can conceal an underdrawing. The infrared emission is calculated by subtracting the luminance of the pictorial layer that is visible under the strongest infrareds. This gives very pertinent observational results that proved to be decisive in the case of the present study (fig. 44).

Benefits of multispectral analysis

The study or analysis of images of such ultra high resolution

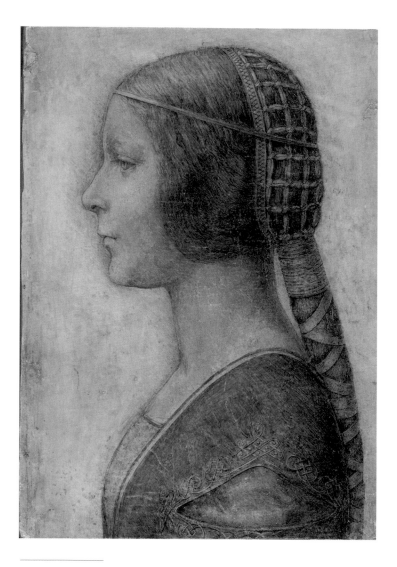

Figure 43

*"La Bella
Principessa"*
reconstructed in
false-colour II

106

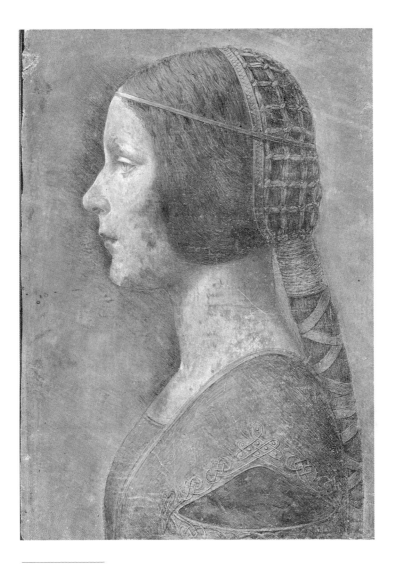

Figure 44

Infrared emission
of *"La Bella
Principessa"*

and high definition gives the researcher a considerable weapon—a trump card, if you will. A few hours spent before a large computer screen, armed with images produced by a multispectral camera, can be invaluable, complementing the evidence obtained in a traditional conservation studio. The high degree of sophistication and extreme precision of multi-spectral images enable an in-depth study of the object's phys-ical characteristics, reducing the need for further direct con-tact, since the work is handled only once in the initial scanning session.

Lumière Technology's multispectral imaging and digitiza-tion system has transformed the discipline, bringing with it many benefits:

- Perfectly clear, ultra high-resolution images;
- Normalized (standardized) colours with a unique level of accuracy;
- A broad spectral range, with infrared and raking light infrared images extended to 1050 nm (instead of the 850 nm possible from film);
- Information that is more pertinent and discriminating.

With this new method of investigation, the colorimetric print was born. Works of art can now be compared on an accurate scientific basis. Moreover, with digital reconstruction, multiple combinations of data can be explored from different points of view and for different purposes. False-colour II images (e.g. fig. 43) are a good example: the infrareds are set off in blue, which is extremely useful for the study of restora-tion campaigns.

3. The Support

The portrait of *"La Bella Principessa"* is executed on a large piece (330 x 239 mm) of vellum or parchment (to use the more generic term for animal skin), which was later laid down on an oak panel.

The vellum

The support is probably the fine-grained skin of a calf. It is characterized by small, natural irregularities, most of which have been reduced in the scudding or scrutching process (figs 45 and 46), in which the skin is rubbed down with an abrasive. The portrait was drawn on the smooth "hair" side, for the "flesh" side would have had a softer, grainier appearance. As

Figures 45 and 46

Details of the vellum support in raking light, showing natural irregularities and blemishes

Martin Kemp has noted in Part I, this is the only known work on vellum in Leonardo's surviving *oeuvre*, though the artist's writings reveal that he was clearly interested in the use of chalk on vellum.

To date the vellum, a tiny sample of the parchment was removed near the edge. This was subjected to carbon-14 analysis, which provided a 95.4% probability of a bracketed date of AD 1440–1650 (fig. 47).[98] This dating confirms that the portrait could well have been made in Leonardo's lifetime, supporting Kemp's proposed date in the mid-1490s and virtually eliminating the possibility that it is a 19th-century pastiche.

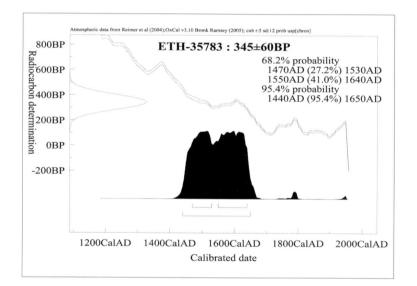

Figure 47

Carbon-14 dating results for the vellum support of *"La Bella Principessa"*

110

The wooden support

The oak panel on which the vellum was laid down has four small x-shaped cleats or butterfly joins (fig. 48), a later intervention undertaken to strengthen or consolidate the panel where it had cracked. At present, we do not know when this intervention was carried out. Nevertheless, the effort to consolidate the work demonstrates that a former owner was clearly committed to safeguarding the portrait. Fortunately, it consisted of only localized restoration, rather than cradling or transfer to another support. Around the edges of the wooden support, there is a paper border that is characteristic of the work of certain restorers and framers.

Figure 48

Back of oak panel on which vellum portrait of *"La Bella Principessa"* is laid down

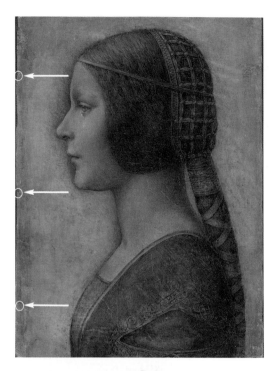

Figure 49

"La Bella Principessa", with circles and arrows marking the three holes that show that it was once part of a gathering sewn into a codex or manuscript

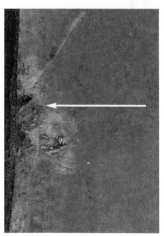

Figure 50

Detail of the central needle hole in figure 49

112

Early history of the vellum support

The presence of the remains of three needle holes along the left edge of the vellum (figs 49 and 50) proves that it originally came from a book or manuscript. During the Renaissance period and before, codices were composed of several gatherings of vellum leaves (quires) stitched together by thread.

The piece of vellum on which *"La Bella Principessa"* was drawn was evidently cut from its codex with a knife: cut marks of *c*.6 cm in length are visible a few millimetres from the lower left edge (fig. 51). These could not have been made with a pair of scissors and are situated exactly at the fold of the gathering of the codex, below the lowest needle hole. (It would be interesting to use the evidence of the nature and placement of these needle holes to look for other surviving quires from the same codex, which, with other physical clues, might shed further light on the provenance and original commission.)

Figure 51

Detail of knife cuts below the bottom needle hole in figure 49, evidence that the portrait was cut from its original codex or manuscript

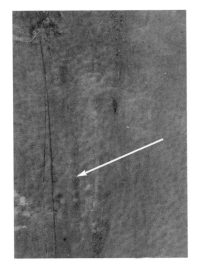

Additional physical evidence on the support

Besides the needle holes, there were several other surprises discovered on the recto of the vellum, including traces of a fingerprint and a small area of pen marks along the left edge of the support—both of which are in the same ink as the main drawing (see fig. 94). Because of the importance of the fingerprint evidence, this is discussed in detail in a separate chapter by forensic expert Paul Biro (see pp. 156–73 below).

The passage of superfluous pen marks, an area of 4 x 7 mm located at the centre of the left edge (fig. 52), was visible in the infrared emission. It is certainly original, doubtless drawn by Leonardo, as can be confirmed by the left-handed orientation, the spectral analysis of the ink and the finesse of the strokes themselves. Are these pen trials by the artist to ensure ink was flowing smoothly from his quill? If so, it is unsurprising that he would have tucked them at the far edge (knowing they would be hidden when the codex was bound).

Unfortunately, since it is laid down on panel (and separation would be hazardous), the verso of the vellum is not visible. It would be interesting to know if there were any further evidence on it, such as a text, inscriptions, traces of further pen trials or fingerprints, etc.

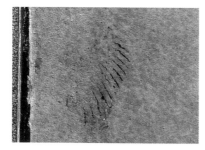

Figure 52

Detail of infrared emission, showing traces of apparent pen trials near left edge of vellum support

4. The Technique

When the portrait was first presented to us, it was described as a watercolour, a coloured drawing, or, alternatively, as a drawing in wax crayons, chalks or pastels. No one was exactly sure of its technique. That the technique had not previously been accurately described is almost certainly due to the later restorations, which masked the media of the original drawing. As already noted, the portrait is drawn on the smooth hair side of the vellum rather than the rough side. This provides an important clue, for some techniques can only be carried out on the flesh side, which results in an entirely different appearance.

The original media: Black, red and white chalk (*trois crayons*), heightened with pen and ink

The multispectral images enabled us to identify accurately the media of the portrait. It is executed in the technique generally termed *à trois crayons*, that is to say, with finely sharpened pieces of natural black, red and white chalks. This mixture was combined with pen and ink, especially in the areas of hatching. Pen and ink was a favourite technique of Leonardo's, as was red chalk (of which he may have been an early pioneer).

Although generally associated with later periods (especially

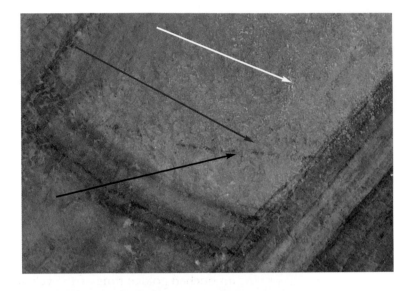

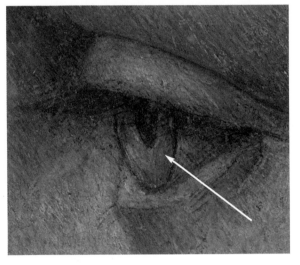

Figure 53 (above)

Detail of neckline, showing technique *à trois crayons* (the arrows indicating traces of original white, red and black chalk)

Figure 54 (left)

Detail of sitter's eye, showing area of blank vellum used to convey the amber iris

the 18th century), the *trois crayons* technique has been used for portrait drawings since the Renaissance. To be completely effective, it requires a toned or coloured support to set off the white highlights. In early periods, artists often exploited the natural flesh colour of vellum or parchment, mixing red and white chalks on top of it to reproduce the sitter's complexion.

In *"La Bella Principessa"*, the basic contours and shadows were executed in black chalk, strengthened in pen and dark brown ink, once again, a typical technique with Leonardo. A detail at the junction of the sitter's bodice and neckline (fig. 53) shows traces of strokes of all three chalks against the flesh-coloured midtone of the vellum. The way in which the artist exploited the support is particularly clear in another detail: the eye, where the untouched golden tone of the vellum conveys the amber colour of the sitter's iris (fig. 54).

The colours of the portrait

If the basic *trois crayons* technique uses only three colours (black, red and white), how does one explain how the artist rendered the sitter's amber eyes, her green, red and yellow costume (fig. 55), or the brown of her hair?

Figure 55

Detail showing the present colours of the sitter's costume (yellow, green and red)

117

Figure 56

Laboratory
reconstruction
of the trans-
formation of
yellow to green
when applied to
a black back-
ground or when
mixed with
black

Jaune de Naples foncé
CI n° 77588, PY 41
1 % ; [1:3]

It is a colorimetric fact that green can be obtained by a dif-
fusion of black pigment on a background of yellow (fig. 56).[99]
This optical peculiarity was exploited by Leonardo to marvel-
lous effect. He conveyed tones of green by applying progres-
sive strokes of black chalk (no doubt sometimes blended with
his finger or the edge of his hand) to the yellowish surface of
the blank vellum. This observation is reinforced by the physi-
cal characteristics of the black chalk, a piece of amphelite,
with its dominant wavelength of 582 nm, which corresponds
to the length of a greenish wave.

The sitter's bodice now appears yellow from the natural
colour of the vellum. Originally, however, it would have been
red, but the red chalk was too fine or too smudged. Traces of

it are still visible at the edges of the trim (fig. 57), but most has been lost from surface abrasion or from having come into contact with moisture. (Because sanguine is a clay coloured by iron oxide, it dissolves easily in water, causing the pigment to disperse.) In fact, the bodice would once have resembled the better-preserved red passage that shows through under the slashed sleeve opening of the green dress. Naturally, traces of red chalk also appear in the modelling of the face and lips. A mixture of red and black chalk, "played off" against the yellow tone of the vellum, was used to obtain the foundation brown colour of the sitter's hair.

Unfortunately, the three coloured zones of the costume—green, "yellow" (as it now appears) and red—as well as the brown of the hair no longer represent the original colours of the portrait in a wholly accurate manner. The pigments have also been overlaid by olive green, yellow and brown wash brushstrokes, which are later additions.

Figure 57

Detail of upper edge of bodice, showing faint traces of red chalk

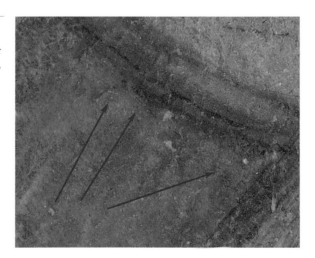

Figure 58

Detail showing original hatching in black chalk (black arrows) and in pen and brown ink (red arrows)

Heightening in pen and ink

After using black chalk for the principal contours and shadows, the artist added further shadows and strengthened or clarified certain details in pen and ink:

- Where the original ink has faded, its transparency (fig. 58: red arrows) allows the underlying strokes of black chalk (fig. 58: black arrows) to show through.
- The pen strokes cover the original chalk, as is proved by the upper eyelashes, where those at the left are in black chalk alone (in gray in fig. 59), while those further along

Figure 59

Detail of sitter's eye in infrared emission, showing lashes in black chalk at upper left, strengthened in pen and ink further to the right and along lower eyelid

120

Figure 60

Detail of sitter's brow, showing pen stroke that overlies white chalk

to the right have additional touches in ink (in black).

- In another detail (fig. 60), the white chalk shows through where the pen stroke has transgressed the contour.
- The ink strokes, often undulating and of varying thickness, seem to "follow" the rhythms and slants of the underlying chalk strokes (figs 60–61).
- The contour of the face is almost entirely strengthened in ink.

These multispectral images reveal two distinct types of ink heightening. The pale, subtly blended strokes (fig. 61: red arrow) are original. The darker, heavier hatched strokes (fig. 61: black arrow) are the retouching of a later restorer; they are exactly the same in character as pen reinforcements on the interlace pattern of the sitter's dress.

Clearly, it would be useful to know what kind of drawing instrument was used to apply the ink by either the artist or the

Figure 61

Detail of sitter's brow, showing original, faded pen hatching (red arrow) and the heavier strokes of a later restoration (black arrow)

restorer. One imagines that Leonardo used a quill pen with a single pointed nib, but further research on this is necessary.

Left-handed hatching

Connoisseurs have long recognized that the single stroke of the pen or chalk is a kind of signature: it translates the thought processes of the artist. Those who can read the "handwriting" can discover the creative mind and inspiration of its author.

The hatching in *"La Bella Principessa"* is highly distinctive, for one can see from both the naked eye and the multispectral images that the strokes are inclined to the left at an angle of about 45°. This is incontestable proof that the artist was left-handed (or at least ambidextrous). The slant of the strokes is easiest to see in the top and left background, where passages of hatched shading are used to set the sitter's head and profile in relief against the flat vellum. Here, in order not to transgress the contour of the face, the strokes move from the lower right (where they are broader) upwards to the left, tapering off at the top (fig. 62).

Figure 62

Detail of left-handed shading in background, above sitter's head (near start of her hairline)

The infrared emission image (fig. 63) is even more revealing. It shows that the left-handed hatching is not limited to the background shading. The internal modelling of the facial features was carried out by means of such finely juxtaposed hatching. As one would expect, in areas of shadow the density of the hatching increases. Moreover, in these areas of hatching, the pen moves from upper left to bottom right (i.e. the opposite of the background shading), as was customary in Leonardo's drawings.

Figure 63

Detail of infrared emission, with extensive left-handed hatching in the sitter's neck

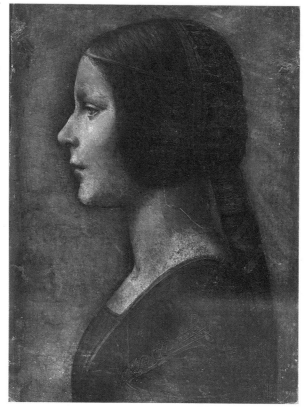

The left-handed strokes of black and red chalk on the face
are clearly visible: they are drawn at the same angle, with the
same regularity and spacing as those of the background. That
they are found throughout the face and neck indicates that the
work was entirely executed by a left-handed artist. Strokes of
white chalk are also evident on the surface: their left-handed
orientation is slightly less clear, since the artist smudged the
powdery white chalk to soften or blend the highlights (fig. 64).

Pentimenti

The three infrared images permit an in-depth exploration of the physical evidence below the visible pictorial layer. The recovery of invisible features such as *pentimenti* at this resolution is extraordinary. It allows us to relive the creative process—as if we were witness to those magical moments or glimpses of pure genius from a man of exceptional gifts.

There are minor adjustments along the profile of the face, neck and shoulder of *"La Bella Principessa"* (fig. 66), similar to those found in the forehead, nose, mouth, neck and chin of the *Portrait of a Woman in Profile* (fig. 65). To judge by the *penti-*

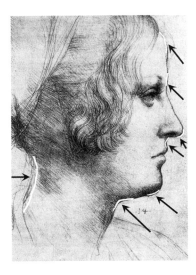 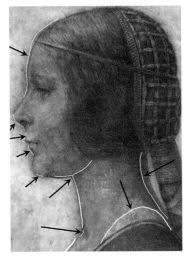

Figure 65

Detail of pentiments to profile of figure 15

Figure 66

Pentiments in *"La Bella Principessa"* (infrared at 1000 nm)

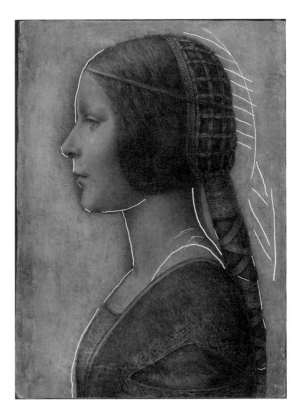

Figure 70

Diagram of
pentiments in
*"La Bella
Principessa"*

menti found in the lips and chins of drawings by Leonardo in both chalk and ink (figs 67–9),[100] the artist seems to have embarked on an almost systematic quest for expressive characterization—an aim clearly pursued in *"La Bella"*. In addition, the images reveal more significant changes to the hair caul and to the shoulder line of the dress of *"La Bella"* (fig. 70).

Erasures

Besides the *pentimenti*, there is other evidence of the artist's changes of mind. The D65 (daylight) image reveals that the

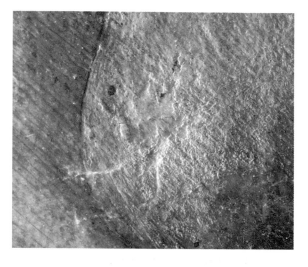

Figure 72

Detail of
sitter's chin in
raking light
(D65), with
losses to
original
chalk layer

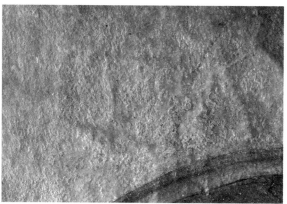

Figure 73

Detail of
sitter's upper
shoulder and
neck in raking
light (D65),
showing losses
to original
chalk layer

especially if the latter is slick or pliant, as is vellum. Where the
white has flaked off in this portrait, underlying strokes of
black and dark red chalk are visible.

Erosion, rubbing and losses of a more general nature are
clearly visible in raking light (fig. 73), in ultraviolet (see fig. 64)
and in the infrared emission (see fig. 44). It is important to

Figure 74

Detail of
bodice in raking
light (D65),
showing surface
marks and
abrasion

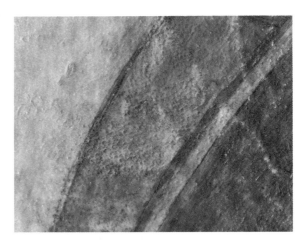

analyse and understand these areas of damage through the
multispectral images, especially since it is no longer easy to dis-
tinguish the colours of the original through first-hand study
with the naked eye. This is particularly evident in the bodice of
the sitter's costume (fig. 74). Because so much of the red chalk
has rubbed or flaked off, the yellow tone of the vellum now
prevails, compromising our ability to "read" and interpret the
work correctly (by weakening, for instance, the allusion to the
Sforza colours of green, red and white).

Damage and alterations to the original ink
Irongall inks are dispersed in a binder (usually gum arabic) that
normally causes them to be absorbed into the support (tradi-
tionally paper). By contrast, pigments without binders remain
on the surface, forming a powdery crust that does not adhere
well and flakes all too easily. Unfortunately, much of the origi-
nal ink was not absorbed into the support of *"La Bella"*, since,
in this case, it was not in direct contact with the vellum but was

laid down largely on top of the chalk to strengthen or clarify certain areas. This has almost certainly led to surface losses to the original ink lines, as well as the chalk strokes. Further changes to the appearance of the ink has resulted from the medium's tendency to blur and become more transparent over time, sometimes eventually fading away to almost nothing.[101]

Restoration map

With the aid of the standardized multispectral images and a cross-comparison of the false-colour, UV and IR, it is possible to construct a map of the apparent restorations (fig. 75).

This map is essential for the study of the portrait's attribution, for it allows the art historian or expert to distinguish clearly between the original media and the pigments added by a later restorer (or restorers). Indeed, in this case, the restorations—the retouching and reinforcement of the original lines and hatching—are, by comparison with Leonardo's own handling, heavy and overemphatic; in a few areas, they compromise the reading of the work.

A thin layer of pink pigment is apparent in much of the cheek area and forehead. This retouching was applied by brush, using a system of hatching. The restorer obviously aspired to be consistent with Leonardo's handling, but, alas, no restorer could achieve the same degree of subtlety as the original draughtsman.

Restoration to the ink

The reinforcements in pen and ink carried out during restoration are easy to recognize. We have identified the ink used by both the original artist and the restorer(s) as a typical irongall

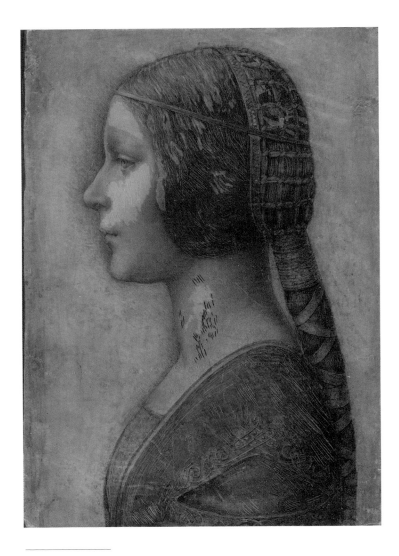

Figure 75

Colour-coded map
showing areas of
restoration in *"La
Bella Principessa"*

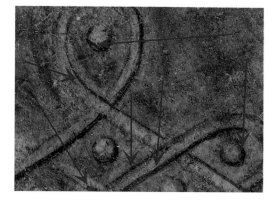

ink (see the spectral analysis in chapter 6), though we are unable to provide the exact composition of either. That of the restoration is much darker than the original, which has faded and blurred in direct proportion to its greater age. This shows up particularly well in the infrared emission, because the ink used by the restorer absorbs more of the infrared light and thus appears darker.

In the knot patterns on the shoulder, the restorer's efforts to reinforce contour lines, details and hatchings are easily distinguished, as is clearly evident in the D65 image (fig. 76). Occasionally, the transparency of the ink in the redrawn areas allows the original black chalk strokes underneath to show through: the original drawing is much more regular. The restorer's stroke is hesitant, sometimes wavers, and is irregular in its thickness. It is not always easy to read. The contrast between the laboured, less coherent and less logical hatching of the later intervention and the lively, correct, refined and harmonious hatching of Leonardo, in which each stroke seems to have a precise role or significance, is abundantly clear from the multispectral images. On the restoration map (fig.

75), the later reinforcements appear in red in the knotwork of the dress and in the hatching in the neck.

It is important to note that the later interventions are the work of a right-handed individual. The movement of the strokes, in contrast to those of Leonardo, starts with a rather timid—even hesitant—placement of the drawing instrument (brush or pen), then continues with a thicker line, with its several nervous wobbles, only to taper off again (fig. 77).

It is worth calling attention to another essential difference between the original hatching and that of the restorer. The

Figure 77

Detail of infrared emission, showing later retouching in ink (black arrows)

Figure 78

Contrast between later hatching (white arrows), which starts only at contour, and original strokes (black arrows), which continue from face into background

Figure 79

Detail of
sitter's lower lip,
showing later
restorer's ink
retouching of
contours

lowest hatchings (i.e. the original strokes underneath the white chalk of the face) continue onto the background (fig. 78: black arrows), whereas those of the restoration stop just short of the contour of the chin or occasionally extend awkwardly over the white chalk (fig. 78: white arrows).

The original contours in irongall ink were selectively re-inforced in the restoration and, again, show up much darker than the original. The handling is much heavier and hesitant and often transgresses or deviates from the original design, as is demonstrated in the following details: the lips (fig. 79), the hair (fig. 80), the decorative knot motifs in the dress (fig. 81) and the contours of the costume (fig. 82).

Restoration to the chalk layer

As already noted, there are extensive retouches in pink. The pigment is mixed with a binder, but there is no evidence of even the faintest craquelure, which may well point to the use of gum arabic. This layer repairs the important facial and neck zones, which were originally drawn *à trois crayons*. The pigment

136

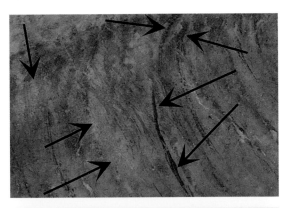

Figure 80

Detail of top
of sitter's head,
showing later
restorer's ink
retouching
in the hair

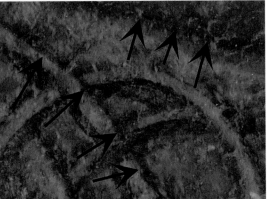

Figure 81

Detail of
sitter's dress,
showing later
restorer's ink
retouching in
knot patterns

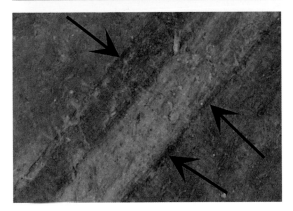

Figure 82

Detail of trim
of sitter's dress,
showing later
restorer's ink
retouching of
contours

Figure 83

Detail of sitter's cheek under ultraviolet: the dull grey areas indicate areas of restoration in opaque pink pigment

of the later retouching shows up as solid, dull grey patches under ultraviolet (figs 64 and 83), contrasting with the original bright white chalk and the intense darks of the original black and red chalk. This is the most extensive area of restoration and the one that most affects the original modelling of the face, with its subtle play of light and shade. The pink pigment is a mixture of lead white and madder lake (see chapter 6 and fig. 96). It covers the most significant losses to the chalk layer, though these remain visible in raking light.

Despite the finesse with which the pink layer was applied in the restoration process, it did not succeed in masking the deep losses to the chalk layer (fig. 84). The damages are also clearly visible in the X-ray (fig. 85), despite being covered by a layer of pink retouching assumed to have a lead-white base (which is normally too opaque to be penetrated by X-rays). We can, in any case, exclude the possibility that the pink contains such anachronistic pigments as zinc white or titanium, since

138

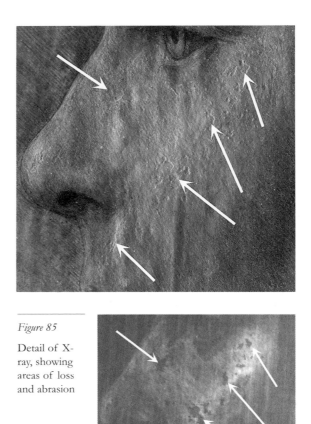

their absorption of ultraviolet light is insufficient.[102] The
appearance of damaged areas in the X-ray can be explained by
the fact that the restorer applied the pink pigment with a
brush, using a system of extremely fine hatching that tries to
follow the orientation of Leonardo's pen and chalk strokes.

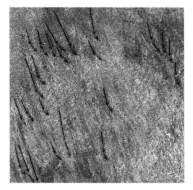

Figure 86

Detail of sitter's neck in infrared, showing the restorer's right-handed brushstrokes

These hatched brushstrokes are visible, for instance, in the neck in an infrared photograph (fig. 86); almost all of the brushstrokes end with a slight hooked movement to the right, a further indication that the restorer was right-handed.

Restoration to the hair and caul

The restoration map (see fig. 75) is colour-coded so that areas of retouching in the hair are indicated in pink, while those in the caul are shown in green. The work in these passages, carried out in a water-based mixture of red ochre and umber, has the same unrefined character as the other restorations.

- The underlying drawing of the hair in ink and red and black chalk has been overlaid by ink and watercolour washes, which nonetheless often allow the original drawing to show through (fig. 87). The darker washes appear to be later additions.
- The pattern of the interlace trim of the hair caul was also reinforced during the restoration(s); the distinction between the original lines and those of the restorer are clear in a daylight image (fig. 88).

140

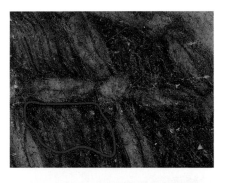

Figure 87

Detail of sitter's hair, showing retouching between knotted ribbons (red arrows) and original passage in red and black chalk (encircled area)

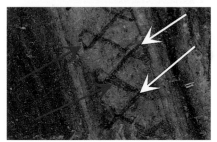

Figure 88

Detail of interlace trim of sitter's caul, showing retouching (red arrows) and original pen lines (white arrows)

Restoration to the green dress

The green of the sitter's dress was entirely reworked with a dilute suspension of green pigment (shown in purple on the restoration map; see fig. 75), modifying the original colour, which would have been very different. The transparency of this wash allows us to imagine what this area might once have looked like, but this zone, more than others, is badly damaged by abrasions, tears, scratches and grazes (fig. 89). This doubtless explains such significant intervention. In addition to the green wash, which distorts the original colour balance, there is again heavy-handed retouching in ink in the knot patterns (see fig. 76), overshadowing the finesse and subtlety of the original design.

141

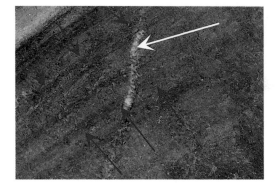

Figure 89

Detail showing later green wash on sitter's dress (red arrows), which conceals damage to the vellum support, such as creases (white arrow)

Restoration of the red bodice

As already stated, the bodice would once have been the same red as the part of the garment visible under the slashed sleeve, but the damage to this area (as in the green dress) is so extensive that initially we—and the restorer—assumed the neckline was meant to be yellow. It was only when the multispectral images, especially those in raking light, picked up the few remaining traces of red chalk (fig. 90) that it became clear that it should have been red. Here, too, the contour of the dress was rather awkwardly strengthened in pen by the restorer, who also applied a thin layer of yellow wash to the bodice.

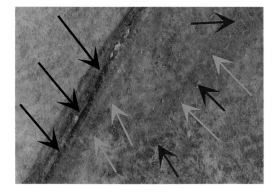

Figure 90

Detail of sitter's bodice showing retouched ink contour (black arrows) and added yellow wash (yellow arrows), as well as traces of the original red chalk (red arrows)

142

6. Spectral Analysis of the Materials

PASCAL COTTE

Spectral analysis enables the pigments and pigment mixtures of each pixel throughout the whole of a work of art to be identified without taking physical samples. In the case of *"La Bella Principessa"*, 40 virtual sample points were chosen for analysis: 25 from the portrait itself (numbered in black on fig. 91), and a further 15 (numbered in white) to analyse the ink in the background (the artist's original hatched shading, the fingerprint and the presumed pen trials). By comparing the spectral "signature" (curve) of each virtual sample against the database of pure pigments compiled by the Optics and Art group of the Institut des NanoSciences de Paris (Université Pierre et Marie Curie–UMR 7588 of the Centre National de la Recherche Scientifique),[103] and, for more complex combinations, against the library of colour declensions assembled by Lumière Technology,[104] we were able to establish the composition of the materials used in both the original drawing and the restoration(s). The physical characteristics of the materials—their appearance, granularity, viscosity and sheen—as well as evidence of damage and losses provided equally useful evidence to confirm the identifications.[105]

Key to virtual pigment samples analysed:

1	Natural colour of blank vellum
2	Pink pigment, type 1 (pale)
3	Pink pigment, type 2 (dark)
4	Pink pigment, type 3 (darker)
5	Red watercolour in hair
6	Brown wash in the trim of hair caul
7	Greenish brown wash in hair
8	Red in lips
9	Original red in cheek
10	Trace of original red in cheek
11	Original dark red at base of nose
12	White under eye
13	White chalk on chin
14	White chalk on shoulder
15	Black stroke on contour of nose
16	Black stroke in iris of eye
17	Black stroke in neck
18	Black stroke at edge of lower lip
19	Hatching at upper nose
20	Ink hatching at bridge of nose
21	Red of bodice under slashed sleeve opening
22	Dark green of dress
23	Yellow of bodice
24	Black chalk in plait
25	Green dot in hair (micro-organism)
26–30	Ink of fingerprint
31–3	Ink of presumed pen trials
34–40	Ink of original hatched shading

144

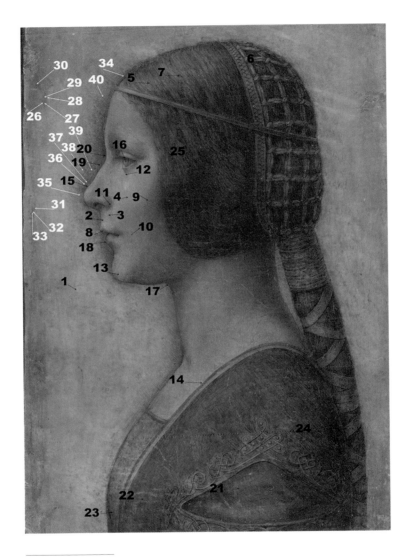

Figure 91

Map of virtual
samples chosen for
spectral analysis

Analysis of the white chalk

Sample nos 12–13 had a very wavy curve (fig. 92), a result that might be explained by interference caused by its granularity. The pixels of the camera (25μm) are close in size to the particles of the chalk. A comparison was made with a white chalk with an oil-based binder, and the undulation remains, though in smaller waves. The spectral curve shows a stronger absorption at lower wavelengths, which gives this white chalk its characteristic friable appearance. The white of the chalk is less white than lead-white pigment.

Analysis of the black chalk

Sample no. 24 had a spectral curve near zero (fig. 93), totally flat from 450 to 900 nm, which is characteristic of high levels of carbon. The black chalk is probably ampelite, a fine-grained black argillite (clay slate) whose colour comes from large quantities of carbon impurities.[106] Known also as Italian chalk, it was often used with red chalk in Italy during the 15th century. The dominant wavelength of ampelite is 582 nm (close to green), underscoring its "verdigris" effect on the dress.[107]

Analysis of the red chalk

The presence of iron oxide is clearly visible in the curve of sample nos 9–10 (fig. 92): the stepped increase in the curve around 760 nm is typical of red hematite. The powdery and chalky appearance that is visible in the macro-details confirms that we are dealing with a fine-grained earthy rock. Red chalk or "sanguine" is a family of earthy, blood-red pigments (hence its name). It comes in pale, dark and purplish-blue shades. It is fabricated from rock containing streaks of ferric or iron oxide.

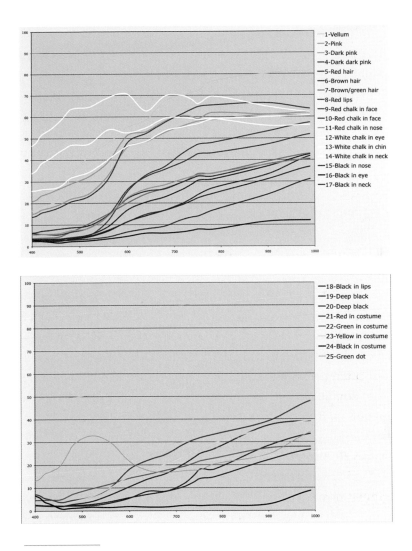

Figures 92 and 93

Spectral curves
of reflected
light on virtual
samples

147

Leonardo mentioned this hard or semi-hard medium, a method he called "dry colouring" (*colorire a seccho*), in the so-called "Ligny Memorandum" (see p. 36), and he employed it in his portrait of *Isabella d'Este* in the Louvre (see fig. 26). The technique seems to have been used in France in the first instance, but Leonardo and his followers developed it extensively. Its popularity culminated in France in the 18th century, after which it waned.

Analysis of the ink

We distinguished two types of ink (fig. 94):

- The original ink (sample nos 26–40), which is easily recognizable by its slightly reddish tone and transparency (as well as by the technique of the strokes themselves, which have a left-handed orientation and are more skilled and regular);
- The ink of the restoration (sample nos 15–20), which is denser and darker (with wavering, irregular and more awkward strokes).

In all the spectral curves of the ink, whether original or later, the presence of iron is indicated by the slight bump at 750 nm (fig. 94: yellow arrow), which is typical of iron sulphate. Even though we cannot identify its precise chemical composition—there are more than 150 recipes for making ink—in both cases the ink is a mixture of irongall, the principal ingredient of classic black ink, which is generally made of gallotannic acid (extracted from oak galls or tree bark) combined with ferrous sulphate and gum arabic. Almost all 15th-century recipes described this type of ink.[108]

Unfortunately, this type of ink is not very stable. Irongall

148

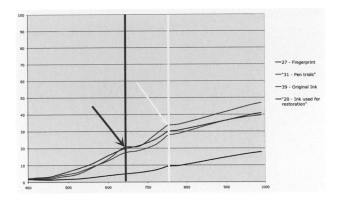

Figure 94

Spectral curves of
original ink samples
(27, 31, 39) and later
retouching (20)

ink starts as a dark purple-black but soon fades to brown, eventually disappearing completely or turning a pale yellow; it can also be highly corrosive, destroying the support (especially paper), due to the oxidation of the carbolic acid (phenol). The transformation of irongall ink over time would explain why the restorer felt the need to reinforce the original pen details and the hatching in the shadows.

The spectral curves of the two inks are very different.

- The ink of the restoration (sample no. 20) absorbs more infrared light, and none of the samples exceed 30% at 1000 nm.
- The original ink (sample nos 27, 31 and 39) is more transparent to infrared and allows the vellum to show through; its values at 1000 nm are always higher than 30%. The presence of a distinctive "bump" at 640 nm is

149

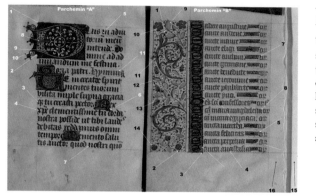

Figure 95

Virtual ink samples of two 15th-century MS leaves subjected to spectral analysis

a specific characteristic of its composition, though we have not yet been able to identify the chemical element that causes it (fig. 94: red arrow).

The spectral curve of the ink of the fingerprint (no. 27) is identical to that of the presumed pen trials (no. 31) and to that of the original drawing itself (no. 39). This provides scientific evidence that all three were made at the same time and from the same ink. Having observed that the pen trials were made by a left hand, everything suggests that it was the same hand that was responsible for the fingerprint smudge.

Finally, the spectral curves obtained from the ink in *"La Bella Principessa"* were compared with those of inks sampled on two manuscript leaves on vellum securely dating from the 15th century (fig. 95). These coincided perfectly.

Although inks cannot be scientifically dated in the same way as vellum or wooden supports (the same recipes continued to be used for centuries), this analysis at least allows us to conclude that the original ink of the portrait is completely compatible with a late 15th-century date.

Analysis of the restorer's green

The multispectral software picked up extensive amounts of an olive green pigment, possibly Bohemian Green Earth (sample no. 22), but the variations in the metameric and colorimetric distributions were too large to identify it accurately. The analysis of this green wash layer was compromised by underlying pigments, because it was applied so thinly.

Analysis of the restorer's pink

The madder lake (sample no. 2) was identified with pigment formulation software (fig. 96),[109] applying the Kubelka-Munk Theory of Reflectance[110] and the solution of the radiative transfer equation (RTE) using the N-flux model (N=6).[111] This is one possibility to obtain a pink tint. Even when applied very thinly, it is very opaque and capable of masking the traces of black and red chalk in the areas of loss.

Figure 96

Computer analysis of the madder lake using Ciba's "Colibri" software

Analysis of the brown tint

As with the red chalk, the spectral curve for sample no. 6 revealed traces of iron oxide, but in smaller proportions. This indicates the presence of dark ochre or raw umber. The heavier of the dark brown strokes are later. The more dilute brown strokes are more difficult to assign confidently to Leonardo or the restorer.

Analysis of random green "speck"

The ultra high resolution of multispectral imaging allows other materials in the pictorial layer to be discerned and analysed. Sample no. 25 (fig. 97) is a tiny speck with a vivid bright green spectral curve. The dominant wavelength is 515 nm, which could be fluorescent. The speck consists of some sort of micro-organism, very probably aflatoxin G (a naturally occurring mycotoxin produced by the fungus *Aspergillus parasiticus*), which is known to fluoresce bright green.[112]

Figure 97

Green micro-organism (only 200 microns large) discovered in the sitter's hair

Virtual reconstruction of the original colours

An idea of the original appearance of the portrait (fig. 98) was reconstructed digitally based on the following assumptions:

• The vellum, naturally soiled by the wear and tear of five centuries, would have been brighter.

- The colours throughout were probably less dirty, less greyish.
- The green was made from a piece of ampelite (dominant wavelength 582 nm) on a yellow background.
- The red of the bodice was achieved with hematite on a yellow background.
- The entire bodice would have been rendered with the same red.

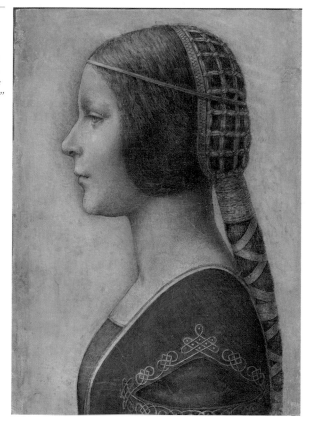

Figure 98

Virtual reconstruction of the original colours of *"La Bella Principessa"*

153

7. X-ray Examination

As is well known, X-rays (a form of radiation with even shorter wavelengths than ultraviolet light) have the physical capacity to penetrate materials. They are absorbed by dense materials and heavy atomic particles, such as bone and lead or other metals, and appear white on photo-sensitive film. They can be very useful and informative in the study and conservation of paintings, but in the present case did not yield significant new findings (fig. 99).[113] A problem with X-rays, unlike multispectral imaging, is that they are not standardized and thus are vulnerable to diverse interpretation.

Because white chalk (calcite or calcium carbonate) does not absorb X-rays to any great extent, the luminous zones of the sitter's face ought to have appeared grey in the X-ray. On the contrary, however, they appear very white here, indicating the presence of a significant amount of dense material in the chalk areas—which seems to contradict all the physical evidence considered so far. In fact, the answer resides not in the material of the portrait, whether original or later, but in the exposure time of the X-ray. In an effort to create a "legible" rather than accurately measured image, the X-ray technician overexposed the plate. This explanation is confirmed by the

Figure 99

X-ray of *"La Bella Principessa"*

fact that certain details appear totally saturated (bright white).

What the X-ray does accurately reveal are the losses to the chalk surface—seen as dark spots or patches in the bright white cheek and brow zones—for these are covered by only a very thin layer of pink pigment, mixed with lead white, too thin to absorb much of the X-rays.

The large vertical white streaks, which follow the grain of the wood, are probably due to some preparation or glue applied when the vellum was laid down on the oak panel.

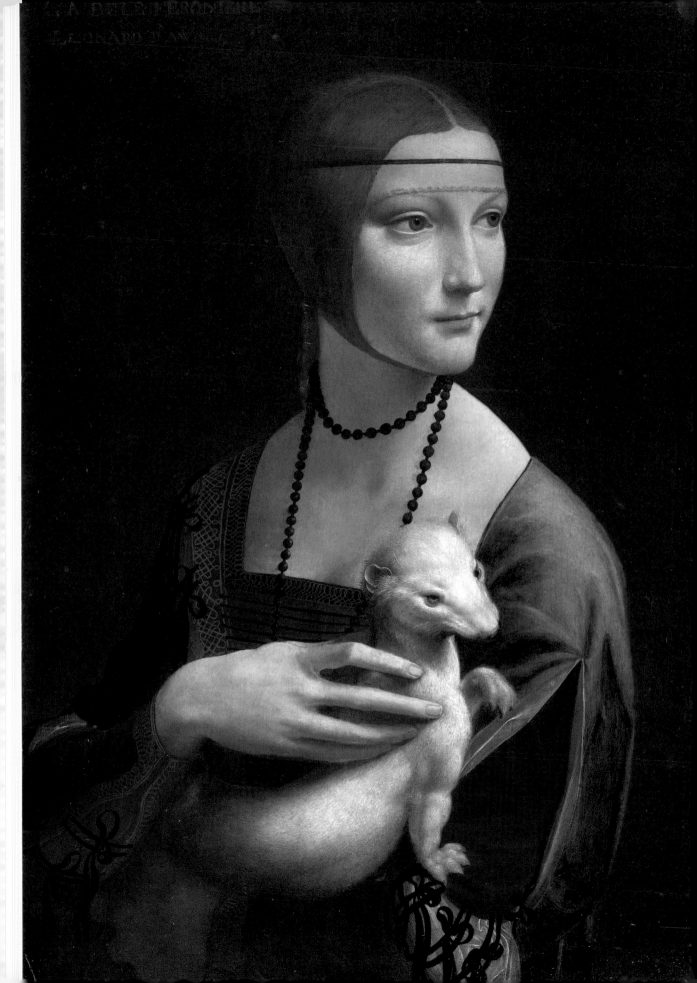

9. Further Comparison with Cecilia Gallerani

PASCAL COTTE

Leonardo's portrait of Ludovico Sforza's mistress Cecilia Gallerani, in the Czartoryski Museum, Kraków, popularly known as the *Lady with an Ermine*, is arguably the Renaissance master's best-known portrait after the *Mona Lisa*. Having been invited by Prince Czartoryski and his foundation to digitize the work with our multispectral camera, we are in a unique and privileged position to use the data gained in that exercise to assess other works by Leonardo from a scientific, technical and formal point of view. Besides the evidence of the similar use of palmprints in the pictorial process, summarized by Peter Paul Biro in the previous chapter, there are further parallels that merit consideration.

Comparison of the eyes

For Leonardo, the eye was the most important element of human expression: "Since the eye is the window of the soul".[124] He made numerous anatomical examinations of the eye, was the pioneer of a highly original method of dissecting the eyeball by hardboiling it in egg white, and designed a large

175

and medium, coupled with the technical examinations, indicate that we are dealing with a work that looks and feels like a Leonardo. We can see that the medium and support have undergone exactly the kind of damage and restoration that we would expect of a work that is over 500 years old. We have been able to detect extensive left-handed execution, not least in layers below those we can see with our naked eye. Finger- and handprints have come to light in the way we have come to recognize as characteristic of Leonardo's working methods. Indeed, the isolated fingerprint near the left margin has strong, if not conclusive evidential value that Leonardo himself touched the vellum.

Ultimately any barrage of evidence—stylistic, historical or technical—has to operate in the context of a sustained, collective sense that the portrait "belongs" to Leonardo and contributes something new to the Leonardo we currently know. *"La Bella Principessa"* seems to me to play this latter role in an utterly convincing way. It reveals a previously unknown dimension to the way in which he fulfilled his duties at the court of Duke Ludovico Sforza. It is his first known portrait of one of the Sforza "princesses", to set alongside the images of two of the duke's mistresses. It shows him using a medium that has not previously been seen in his *oeuvre*, but one that relates closely to his interest in the French artist Jan Perréal. It shows his responsiveness to a very particular setting, within a manuscript of vellum, that demanded a special kind of formal beauty. It reveals a new facet of his direct engagement with the ranks of the court poets, who were his collaborators and rivals. It exhibits, above all, a thrilling freshness and "perfection" perfectly adapted to the sitter's delicate precocity.

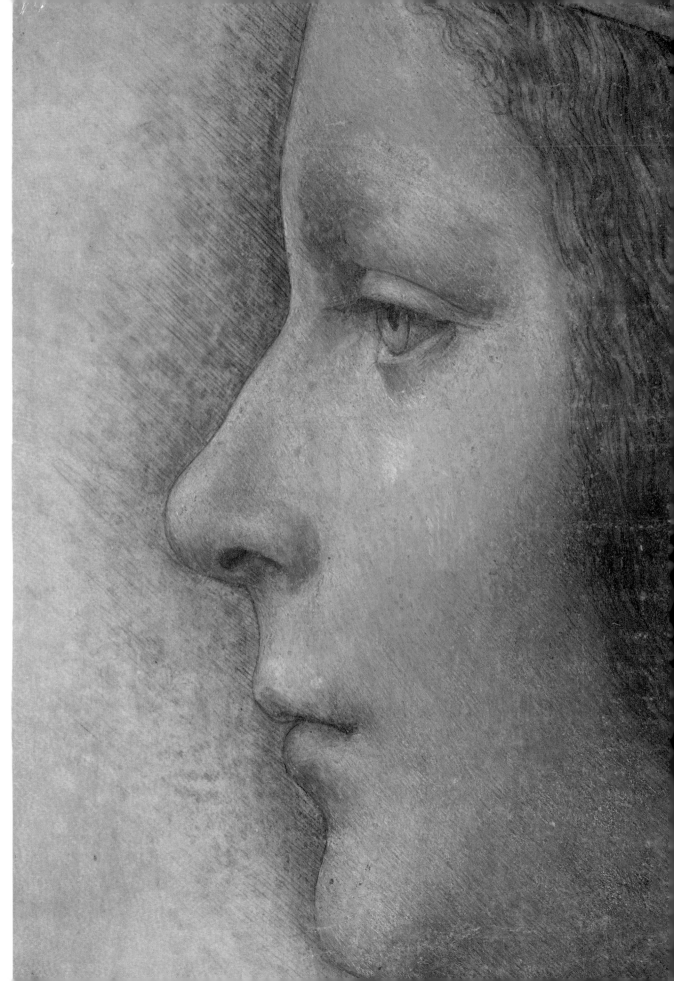

9. See Cennino Cennini: *Il libro dell'arte* (MS, *c.*31390); ed. and trans. by D.V. Thompson as *The Craftsman's Handbook* (New York, 1933).

10. *Codice atlantico* [hereafter "CA"], Milan, Biblioteca Ambrosiana, fol. 669r; see E. Villata, ed.: *Leonardo da Vinci: I documenti e le testimonianze contemporanee* (Milan, 1999), no. 141.

11. CA 669r: "*Piglia da Gian de Paris il modo di colorire a seccho e'l modo del sale bianco e del fare le carte impastate, sole e in molti doppi, e la sua casetta de' colori. Impara la tempera delle conrnage. Impara dissolvere la lacca gomma.*" The next sentence in Leonardo's note is unclear in meaning. The "Ligny Memorandum" is conventionally dated 1499, but the circumstances fit better with Charles VIII's ultimately ill-fated expedition to Naples in 1494.

12. London, Victoria & Albert Museum, Codex Fortster II², fol. 159r : "*Per fare punte da colorire a secco; la tempera con in po' di ciera e non casherà, la qual ciera disolverai con acqua, che temperata la biacca essa acqua stillata ne vada in fumo e rimanga la ciera sola, e farai bone punte. Ma sappi che bisogna macinare i colori colla pietra calda.*" See C. Pedretti: *Commentary to the Literary Works of Leonardo da Vinci,* 2 vols (Oxford, 1977), i, pp. 359–60.

13. CA 225a/611a: "*la misura del sole promessarmi da maestro Giovanni Francese*".

14. Windsor Castle, Royal Library, inv. no. RL 19019r; see K. Clark and C. Pedretti: *The Drawings of Leonardo da Vinci in the Collection of Her Majesty the Queen at Windsor Castle,* 3 vols (London, 1968), iii, p. 10, repr.

15. See the excellent overview by Tom Tolley in *The Grove Dictionary of Art* (New York and London, 1996), xxiv, pp. 471–2. See also R. de Maulde La Clavière: *Jean Perréal dit Jean de Paris* (Paris, 1896); A. Vernet: "Jean Perréal, poète et alchimiste", *Bibliothèque d'Humanisme & Renaissance*, iii (1943), pp. 214–52; J. Dupont: "A Portrait of Louis XII Attributed to Jean Perréal", *Burlington Magazine*, lxxxix (1947), pp. 235–9; G. Ring: "An Attempt to Reconstruct Perréal", *Burlington Magazine*, xcii (1950), pp. 255–60; P. Pradel: "Les Autographes de Jean Perréal", *Bibliothèque de l'École de Chartes*, cxxi (1963), pp. 132–86; and C. Sterling: "Une Peinture certaine de P. Perréal enfin retrouvée", *L'Oeil*, ciii–civ (1963), pp. 2–15, 64–5.

16. For copies of Perréal's poem in which Nature chastises the alchemist for his erring ways, see London, British Library, MS Stowe 955 (Pierre Sala: *Petit Livre d'Amour*, Central [Paris] and S.E. Lyon, *c.*1500, ff. 1+34); and Paris, Bibliothèque Sainte-Geneviève, MS 3220 (J. Perréal: *Les Remonstances de Nature à l'Alchemiste errant, c.*1516).

17. Jean Lemaire de Belges, *La Plainte du Desiré* (Paris, 1509); repr. in J. Stecher, ed.:

Oeuvres de Jean Lemaire de Belges, 4 vols (Louvain, 1882–91), iii (1885), p. 162: "*Besognez doc, mes alumes moderns, / mes beaux enfans norris de ma mamelle, / toy Leonard qui as graces supernes, / Gentil Bellin dont les loz eternes, / et Perusin que si bien couleurs mesle: / et toy Jean Hay* [Fouquet], *ta noble main chomme elle, / voir Nature avec Jean de Paris / pour luy donner ombrage et esperits.*"

18. Chantilly, Musée Condé, inv. no. DE PD 397. Silverpoint; 200 x 137 mm; see S. Béguin: *I disegni dei maestri, 5: Il cinquecento francese* (Milan, 1970), fig. 1.

19. Paris, Bibliothèque Nationale de France, Département des Estampes, inv. no. Rés Na 21, fol. 28. Black, red and white chalks; 263 x 178 mm; see F. Avril, ed.: *Jean Fouquet: Peintre et enlumineur du XVe siècle* (exh. cat., Paris, Bibliothèque Nationale de France, 2003), p. 151, pl. 15 (in colour). For these early chalk portraits, I am deliberately avoiding the term "pastels", which is better reserved for the more specifically defined medium that was perfected in the 18th century.

20. See P. Mellen: *Jean Clouet: Complete Edition of the Drawings, Miniatures and Paintings* (London, 1971), p. 28, repr. (in colour). Clouet spoke in 1511 about making a drawn portrait in "*demi-couleurs*" (semi-coloured); scc ibid., p. 26.

21. St Petersburg, State Hermitage Museum, inv. no. N OR 2856. Black and red chalk; 181 x 129 mm; see I. Novosselskaya: *Le Dessin français de XVe et XVIe siècles dans les collections du musée de l'Ermitage* (exh. cat., St Petersburg, Hermitage, 2004–5), p. 22, repr. (in colour).

22. See G. Bora in *The Legacy of Leonardo: Painters in Lombardy, 1490–1530* (Milan, 1988), p. 102.

23. Milan, Pinacoteca de Brera, inv. no. Gen. 150. Black and dark red chalks and pastel on pale green paper, with extensive retouching in red and black chalks and with brush and tempera and bistre ink; 400 x 320 mm; see P. Marani: *Leonardo e i leonardeschi nei musei della Lombardia* (Milan, 1990), no. 62, repr. (in colour). Long regarded as one of Leonardo's most beautiful drawings, it is clear that most or all of what we now see is not drawn with the left hand. It has been suggested that it may be an original Leonardo drawing that has been comprehensively reworked.

24. Milan, Pinacoteca Ambrosiana, inv. no. Cod. F. 290 inf. 8. Brown, yellow ochre, red and ivory chalks, over charcoal, on paper prepared with a cream-coloured ground; traces of stylus incisions on some outlines; 537 x 407 mm; see C. Bambach, ed.: *Leonardo da Vinci, Master Draftsman* (exh. cat., New York, Metropolitan Museum of Art, 2003), no. 128, repr. (in colour).

25. Vienna, Graphische Sammlung Albertina, inv. no. 243. Black chalk, pen and ink, brush and traces of white heightening; 374 x 246 mm; see Bora 1988, pl. 4.12.

Renaissance Studies, xxii (2008), pp. 1–29. I am grateful to Evelyn Welch for assistance with the Sforza court fashions. See also Grazietta Butazzi in B. Fabjan and P. Marani, eds: *Leonardo: La dama con l'ermellino* (exh. cat., Rome, Palazzo del Quirinale, 1998), pp. 67–71.

51. *Messale Arcimboldi*, *c*.1494, Milan, Biblioteca del Capitolo Metropolitano, MSS II.D.1.113, fol. 8r.

52. Two of the kneeling women in an altarpiece of the *Madonna, Child and Saints with Donors* attributed to the Master of the Pala Sforzesca in the National Gallery, London (inv. no. 4444; oil on panel; 55.9 x 48.9 cm), wear more downmarket versions of the *coazzone*.

53. Oxford, Christ Church Picture Gallery, inv. no. JBS 156. Oil on panel; 51 x 34.5 cm; see J. Byam Shaw: *Paintings by Old Masters at Christ Church, Oxford* (Oxford, 1967), no. 156, repr.

54. Florence, Galleria degli Uffizi, inv. no. P98 [8383] (as Alessandro Araldi). Oil on panel; 46.5 x 35 cm; see Byam Shaw 1967, fig. 31.

55. For the iconography of Beatrice, see F. Malaguzzi-Valeri: *La corte di Lodovico il Moro*, 3 vols (Milan, 1913), esp. iii, pp. 26–30.

56. For instance, a version of the Ambrosiana profile of a woman with a lavish set of pearls (see note 60 below), overpainted seemingly as a St Catherine, is in the Ashmolean Museum, Oxford (inv. no. WA 1945.63; oil on canvas; 46 x 33.7 cm; see C. Lloyd: *A Catalogue of the Earlier Italian Paintings in the Ashmolean Museum* [Oxford, 1977], pp. 96–8, no. A713, repr.), and a version of the Washington *Bianca Maria Sforza*, showing the sitter only to the mid-level of her upper arm, is in the Louvre (inv. no. RF 2086; oil on panel; 47.5 x 36.8 cm; see A. Brejon de Lavergnée and D. Thiébaut: *Catalogue sommaire illustré des peintures du musée du Louvre: Italie, Espagne, Allemagne, Grande-Bretagne et divers* [Paris, 1981], p. 152, repr.).

57. See Byam Shaw 1967, pp. 92–3.

58. See Malaguzzi-Valeri 1913, i, p. 37: "*una bella collana cum perle grosse ligate in fiori d'oro et uno bello zoglielo da attachere a dicta collana, nel quale è uno bellissimo smiraldo de grande persona, et uno balasso et una perla in forma de un pero*".

59. See D. Godefroy: *L'Histoire de Charles VIII* (Paris, 1684), pp. 709–10: "*Premierement, quand elle arriva elle estoit sur un coursier accoustré de drap d'or & de velours cramoisy, & elle une robbe de drap d'or verd, & une chemise de lin ouvrée pardessus, & estoit habillée de la teste grande force de perles, & les cheveux tortillez & abbatus avec un ruban de soye pendant derriere, & un chapeau de soye cramoisy fait ny plus ny moins comme*"

les nostres, avec cinq ou six plumes grises & rouges audit chapeau, & avoit cela sur la teste, & estoit sur ce coursier en façon qu'elle estoit toute droite, ny plus ny moins que seroit un homme, & estoit avec elle la femme du Seigneur Galleas, & plusieurs autres jusques au nombre de vingt-deux, toutes sur haquenées belles & gorgiaises, & six chariots couverts de drap d'or & de velours verd, & tous pleins de Dames …. le lendemain après disner ledit Seigneur les alla voir, là où elle estoit merveilleusement gorgiaise à la mode du pays, laquelle estoit une robbe de satin verd, don't le corps estoit chargé de diamans, de perles, & de rubis, & autant derriere que devant, & les manches bien fort estroites, toutes déscoupées en telle façon que la chemise parvissoit. Estoient ces coupes toutes attachées avec un [sic?] grande ruban de soye grise pendant Presque iusques en terre, & avoit la gorge toute nuë, & à l'entour tout plein de perles bien fort grosses, avec un rubi qui n'est gueres moins grand que vostre grand valloy, & de la teste estoit habillée tout ny plus ny moins que le iour d'auparavant, reserve qu'au lieu de chapeau elle avoit un bonnet de velours avec des plumes d'egrette, là où il avoit une bague de deux rubis, un diamant, & une perle en façon de poire, laquelle poire est toute de la forte de la vostre…. Si n'estoit que le Roy vous veut envoyer la peinture d'elle, & la façon dont elle estoit habillée, i'eusse mis peine de la recouvrer pour la vous envoyer"; the Eng. trans. is from J. Cartwright: *Beatrice d'Este, Duchess of Milan (1475–1497): A Study of the Renaissance* (London, 1903), pp. 235–6.

60. Milan, Pinacoteca Ambrosiana, inv. no. 100. Oil on panel, 51 x 34 cm; see Zöllner 2007, p. 98, repr. (in colour).

61. I am inclined to retain the identification of the sitter as Ludovico's mistress Lucrezia Crivelli and to assign it a date of *c.*1497. It has recently been suggested by Jacqueline Musacchio, in A. Bayer, ed.: *Art and Love in Renaissance Italy* (exh. cat., New York, Metropolitan Museum of Art, 2008), p. 34, that a profile portrait, attributed to Ambrogio de Predis, of a relatively mature lady in the National Gallery, London (inv. no. NG5752; oil on walnut; 52.1 x 36.8 cm), who wears a girdle adorned with a moor's head buckle, is Lucrezia, but she is not dressed in the post-1491 fashion. She may more plausibly be identified as Bernardina de Corradis, Ludovico's mistress and the mother of Bianca, his legitimized daughter (who is discussed in detail below).

62. Windsor Castle, Royal Library, inv. no. RL 19058v. Pen and brown ink, over traces of black chalk; 183 x 130 mm; see Zöllner 2007, no. 258, repr. (in colour). See also inv. nos RL 19058r, 19057r, 19057v and 19059r (see ibid., nos 257, 260, 259 and 261 respectively, all repr. [in colour]). For Leonardo on the subject of edge contrasts, see particularly Urb. 75r–77v (see Kemp [ed.] 1989, pp. 72–3); and M. Kemp: "In the Beholder's Eye: Leonardo and the 'Errors of Sight' in Theory and Practice" (Hammer Prize Lecture), *Achademia Leonardi Vinci*, v (1992), pp. 153–62.